HOW TO PAINT SONGBIRDS

A Guide to Materials, Tools, and Technique

David Mohrhardt

Stackpole Books

Published by
STACKPOLE BOOKS
Cameron and Kelker Streets
P.O. Box 1831
Harrisburg, PA 17105

Printed in the United States of America

10 9 8 7 6 5 4 3 2 1

Book and jacket design by Tracy Patterson

LIBRARY OF CONGRESS
Library of Congress Cataloging-in-Publication Data

Mohrhardt, David.
 How to paint songbirds : a guide to materials, tools, and
technique / by David Mohrhardt.
 p. cm.
 1. Painting—Technique. 2. Birds in art. I. Title.
ND1380.M64 1989
751.42′2432—dc19 88-16065
 CIP

To Anna

Contents

Introduction

Songbirds are familiar to everyone. Because they are so adaptable, they are found in almost any environment, from city park to country woodland. Their variety of shape, size, and color is amazing, providing us with entertainment as well as beauty.

In summertime, a meadowlark perched on an old fence post puffs out its yellow and black breast, raises its head, and bursts into song. It is a memorable moment, and although the meadowlark's song cannot be captured by the artist, its beauty and "personality" *can* be. Student, bird-watcher, and fledgling artist alike have a desire to accurately portray scenes like the singing meadowlark, but most lack the basic knowledge to get started painting birds. This book is intended not only to get you started, but to advance you well along the way to successful songbird painting. It will guide you through the myriad art supplies available, suggesting those that are best for bird painting. Basic painting techniques are described, as well as an introduction to bird anatomy and attitudes. Finally, this book will show you how to apply all you have learned to create a realistic songbird painting, using step-by-step examples. Though the focus here is more toward painting on flat surfaces, many of the materials, tools, and techniques may be applied to painting carved birds.

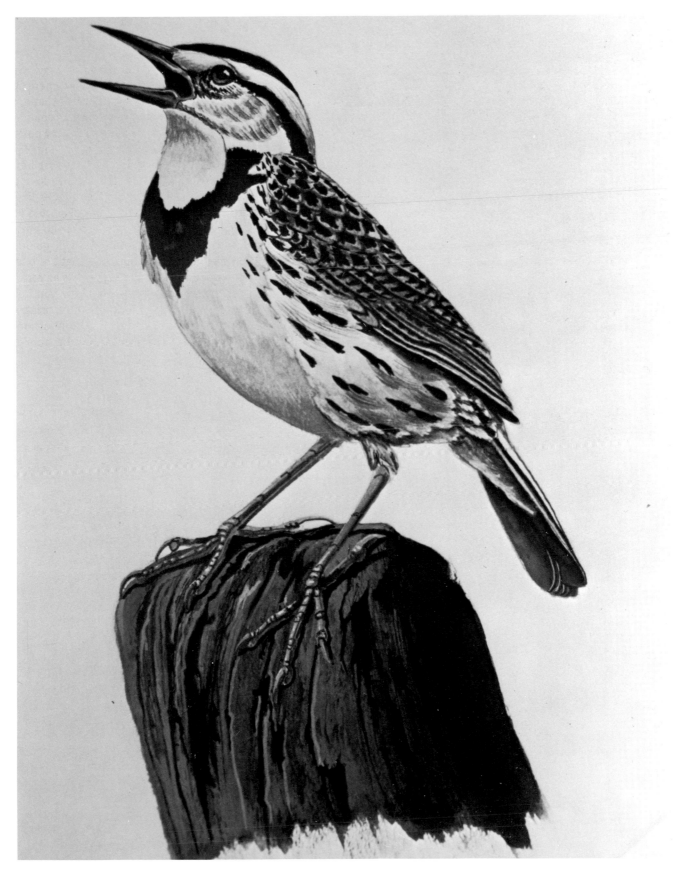

1
Painting Mediums

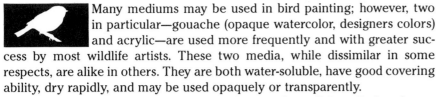 Many mediums may be used in bird painting; however, two in particular—gouache (opaque watercolor, designers colors) and acrylic—are used more frequently and with greater success by most wildlife artists. These two media, while dissimilar in some respects, are alike in others. They are both water-soluble, have good covering ability, dry rapidly, and may be used opaquely or transparently.

Oil paints and transparent watercolors are beautiful media but do not lend themselves easily to bird painting. Oils require oil solvents as a thinner, are rather thick to work with, and dry quite slowly. They may be used thinly, but this technique requires a great deal of experience. The newer water-based "oil" paints are thinned by water but work in a manner similar to traditional oils. Conversely, transparent watercolors are applied very thinly and dry quickly. Their great disadvantage is their inherent transparency, which means that it is hard to cover one color with another, and mistakes are difficult to correct.

A word of caution here: whichever media you choose to work in, know that many of the pigments used are toxic or carcinogenic in one degree or another. This does not mean that under normal conditions painting is hazardous to your health; it merely means that you should use common sense. After painting, wash your hands before eating or smoking, or if there is excess paint on your hands because some toxic materials may be absorbed through the skin. And *never* point your brush by putting it in your mouth.

You can purchase a wide variety of premixed colors, but it is wise to get only a few basic ones (red, yellow, blue, green, black, white, raw umber, burnt sienna), work with them, and then buy additional colors as needed. Whether you are a beginner or an expert, painting is easier with a limited palette.

Color mixing in any medium is almost an art in itself. It would be best to familiarize yourself with the basics of colors and color mixing by getting a beginner's book on color theory and then experimenting, blending colors to obtain the best results. When you obtain a desired color, either while experimenting or while involved in a painting, make a note of which colors were mixed to obtain that color. Never trust your memory; later you may attempt to duplicate a particular color and not be able to do so. Making color notes is tedious but worthwhile.

Gouache

Gouache is the easiest medium to work with because of its forgiving qualities; its opaqueness allows mistakes and corrections to be made and the paint remains workable even when dry, permitting blending and scrubbing out of colors.

Gouache may be used thinly to give a very transparent color, layers of color may be allowed to build up, or it may be used in a completely opaque manner with darks over lights, or vice versa. Whichever effect you choose, it is accomplished with the addition of water to the concentrated pigment. However, gouache should not be used too thickly or it will crack.

The dry gouache paint has a matte, nonglossy finish and great visual weight. It is available in a wide variety of colors, but, as with most pigments, the degree of *light-fastness* (permanence) can vary widely.

Most color charts have a key that indicates the light-fastness of the various colors. The ratings are: (E) Excellent; (V) Very Good; (G) Good; and (F) Fugitive. For art that is to last, it would seem folly to use any colors below the Very Good rating. Not only does the permanence of color vary, but same-named colors from different manufacturers can have very different color values, especially in the earth tones. The best approach is to familiarize yourself with the color differences between the brands via color charts, which are available free or at a nominal cost from the manufacturers or art-supply stores, then choose the colors and brands you are most comfortable with.

When you look at the color charts you will notice the great variety of shades of the basic colors (reds, yellows, blues, etc.), but don't ignore the blacks, which have color characteristics all their own. *Ivory* (bone) *black* has a brownish tone, *lamp black* has a bluish tone, and *mars* (jet) *black* is a deep velvet black. When mixed with other colors or white they give very different results.

Gouache may be purchased in tubes, cakes, or jars, with tube gouache being the most readily available. The paints in tubes and jars remain workable over a long period of time as long as the caps are kept securely in place. The key is to keep air away from the paint, especially in tubes where the paint is more viscous to begin with. After squeezing needed paint from a tube, whether transparent watercolor, oil, acrylic, or gouache, never squeeze the sides of the tube to suck the paint back in—this only allows excess air into the tube and accelerates drying in the tube. With gouache and acrylics it is advisable to put only the colors you are going to use on the palette as you need them because they will dry out on the palette. The gouache may be worked when dry, but acrylic will dry completely, rendering it useless.

A shortcoming of gouache is that because it remains water-soluble even when dry, it is possible for a color already painted on a picture to bleed through into another color applied over it if the second color is worked too much with the brush. Even when dry, the surface of gouache will rub off slightly with vigorous movement, so it is advisable to place a small piece of paper under that part of your hand that is touching the art so that traces of color already applied are not picked up and dragged around.

Despite the minor disadvantages of gouache, it is still the most versatile and easiest medium to use in bird painting on flat surfaces and is the first choice of beginners and experts alike.

Gouache Media

Gum arabic is the basic binder used in the manufacture of gouache. It is also used, in small quantities, to increase the transparency of gouache and impart a slight gloss to the normally matte finish. It is most commonly available in small jars.

Ox gall is made from the bladders of oxen. This natural wetting agent is the best material to increase the uniform flow of gouache, particularly in washes. Only small amounts are used, and it is available in small jars.

Acrylics

As mentioned previously, gouache and acrylic have much in common:

rapid drying time, water solubility, opaque or transparent use. But there the major similarities end. While acrylics and gouache are suitable for painting on flat surfaces, acrylics are best for painting birds in the round, whether wood or clay. The basic color selection of acrylic is not as broad as gouache, and is available only in tubes and jars. Again, color charts should be consulted for the variety of colors available. The consistency of the paint in tubes and jars is quite different: the paint in jars is less viscous and easier to thin to a flowing or brushing consistency.

One of the difficulties a beginner encounters is in achieving the proper working consistency for acrylics. Whereas gouache cannot be used thickly, acrylic may be used from a transparent wash to a thick impasto; obviously, the working consistencies can vary widely. A rather disconcerting quality of acrylics, especially for beginners, is that even though they may appear to be opaque and dense on the palette, they work very thinly on the painting surface and it may take two or three applications to achieve a solid color, if indeed that is your intent. There is no formula; only experimentation and experience will teach you the right "feel" for the particular painting being done.

The short drying time of acrylic paints cannot be emphasized too much simply because when acrylics dry, they are *dry*: they become extremely hard and are not water-soluble. This means that wet-in-wet blending between colors must be done while the paints are still workable; however, a blended or shaded effect may be achieved if a graded wash is put on over an already dry color (see Techniques). The hard nonsoluble surface is a distinct advantage when applying glazes (thin washes of other colors) or other solid colors over an already painted surface because the paints will not bleed into one another. The surface of dry acrylics will not rub off, thus your painting hand won't drag colors around.

Acrylics have excellent permanence and may be used on virtually any surface. A ground coat of gesso is necessary on many surfaces, especially canvas, wood, and clay. The colors have great visual weight and look juicier and brighter than gouache; the surface of the dry paint has a slight sheen.

The big precautionary note for acrylics is that, because of their rapid and hard drying qualities, care must be taken to clean brushes and other tools immediately after use because dry acrylic is virtually impossible to remove from many surfaces, including clothing and floors.

Initially, acrylics seem difficult to control, but don't be dismayed by first attempts—work with them until you've mastered their use. They are a valuable and versatile medium, whatever the painting surface.

Acrylic Media

Acrylic retarder is a gel that retards the drying time of acrylic paint. It is usually available in tubes. Care must be taken to add the proper amount of retardant to the paint; the instructions on the container should be followed.

Acrylic flow release is added to acrylics in small amounts to reduce surface tension, thus increasing the flowability and permitting more even washes on paper or paperboard.

Acrylic gel medium is a thickening material that not only allows an impasto effect to be achieved, but makes the paint more transparent. It has very limited uses in bird painting.

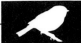

2
Brushes

 Almost any hair, bristle, or fiber may be used in the manufacture of brushes for painting, and all have different characteristics.

The brush is the most important tool in bird painting. There is nothing more frustrating or self-defeating than trying to work with a poor brush. Purchase the highest quality brush(es) you can afford. Don't be dismayed at the array of shapes and sizes; only a few good brushes are necessary for successful bird painting.

What determines a good brush is a combination of abilities: to carry an adequate load of paint, to hold a sharp edge in a flat brush, to hold a sharp point in a round brush, and to spring back into shape after use. Emphasis here will be on the materials and shapes used most frequently in bird painting with gouache and acrylic paints.

Types of Hair and Filament

Kolinsky Sable. The finest and most expensive brushes made are from Kolinsky sable, but even these will vary in quality depending on the manufacturer. Kolinskys are typically found in the round shape and usually display all of the desirable qualities of a good brush. Although there are many brands, the two I recommend for availability and consistent quality are the Strathmore series 585 and the Winsor & Newton series 7.

Red Sable. Sable hairs that are of a lesser quality than Kolinsky, usually they are not as springy, and in rounds do not point up as well as Kolinskys. In other shapes—flats and filberts—they are fine brushes.

Sableline. A fancy name for dyed ox hair. They do not point up well in the rounds but have the ability to hold a good load of paint and are fine flat and large wash brushes.

Nylon. Sometimes designated as synthetic sable, nylons have great spring but little ability to point or hold paint. The development of synthetic filaments has not yet achieved the quality found in natural hair brushes.

Blends. The most common blend is nylon-sable, and although a better brush than pure nylon, it is still lacking in paint retention and the ability to hold a fine point.

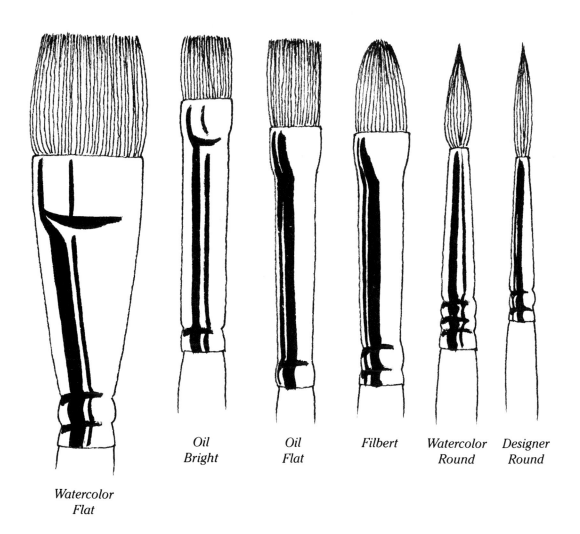

Watercolor
Flat

Oil
Bright

Oil
Flat

Filbert

Watercolor
Round

Designer
Round

Brush Shapes

Shapes of Brushes

Standard Round. Usually just called a "round," this is the most popular and versatile shape, found in a variety of sizes. Though this is called a *standard* round, various characteristics such as hair length may vary between manufacturers. The two most popular brands are Winsor & Newton and Strathmore. The brush I recommend in this style is the Strathmore Kolinsky Sable #585, an all-around good brush that holds a very fine point.

Designer Round. These have a longer, thinner shape than a standard round and come to a narrow sharp point that can pull a very fine line. This is a good style but not quite as versatile as the standard round.

Flat. There are two categories to be considered in this style: watercolor and oil flats.

Watercolor flats. Initially, this brush category may seem confusing because watercolor flats may also be called *aquarelles*, which are large, thick flats or one-stroke brushes that usually have slightly longer hairs than do normal flats. Regardless, they are all watercolor flats and all are used primarily for washes or filling in large areas. They are generally not found in very small sizes, and the most common sizes are $1/4$, $3/8$, $1/2$, $3/4$, and 1 inch. Red sable and sableline are the preferred hairs in this shape; lesser-quality brushes in this shape have a ragged edge, don't hold much paint, and have the annoying habit of losing hairs in painting. Another brush to be considered here is a large flat called a *wash brush*, used, as the name implies, for putting washes on large flat surfaces. A good large wash brush is the $1 1/2$- or 2-inch Oxhair by Strathmore.

Oil flats. These come in a much greater variety of sizes, have shorter hairs, and are more stout than watercolor flats. Oil flats are used for oils and acrylics on canvas or wood. The *bright* is another flat but with slightly shorter hairs than the oil flat.

Filbert. This is a flat but with a rounded rather than a square tip. Traditionally regarded as an oil-painting brush, it is now an important shape for painting birds in gouache and acrylic as well. Used in an unconventional manner it produces unique featherlike marks (see Techniques). The various sizes of this brush make different sizes of feather marks, and which size you will need is determined by the size of the bird being painted. The different types of hair in this style make different types of marks. Red sable would be the best hair choice to start with, but be sure to experiment with other types of hair and bristle.

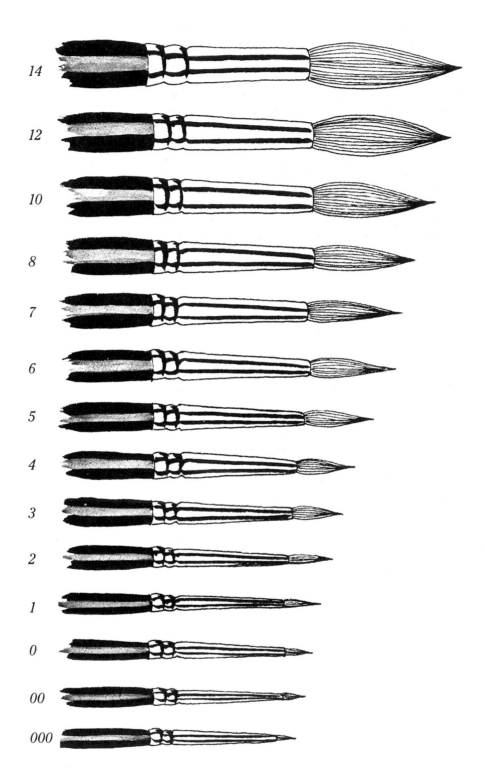

14

12

10

8

7

6

5

4

3

2

1

0

00

000

Watercolor Rounds (Actual Size)

Care of Brushes

Several good brushes may represent a considerable investment and it is wise to care for this investment with the small amount of time it takes to keep brushes in good condition. Cleaning water-based paints from brushes only requires rinsing them thoroughly in body-temperature water, then gently scrubbing them with a pure soap such as Ivory bar soap. After rinsing all the soap out, reshape the tip of the brush and hang it hair- or bristle-down to dry. When you are using several brushes it is difficult to stop painting and clean them. In cases like this, there is a piece of equipment called a brush washer or brush holder. It is merely a container of water with a coiled-spring metal holder mounted above the water level. When the brush handle is put in the coil, the hairs may be suspended in the water, keeping the paint in the brush moist until it can be washed out thoroughly.

If you have extra brushes or some that are used infrequently, store them in a closed—but not airtight—container along with some moth crystals (moth larvae love to munch on hairs and bristles). With proper care some brushes may last a lifetime, but even if the ends wear off they are still useful (see Techniques).

Buying Brushes

The ideal way to buy a brush is to go to an art-supply store where you can test it before buying; it is especially wise to test sable rounds of any quality. Testing merely involves wetting the brush in water to remove the manufacturer's starch (used to protect the brushes), then, when it is thoroughly wet, flick the brush quickly to see if it points well. After that, press the damp hairs sideways on a hard surface and release them to see if the brush snaps back into shape. If the brush behaves well, buy it; if not, repeat the performance with another brush. Oftentimes it is necessary to order brushes from a mail-order company. Just stick with reliable brands and you will usually be pleased. If not, most firms have a return policy.

The recommendations here are to be used only as a guide. All artists have individual preferences and the best way to satisfy your artistic needs is to experiment until you find which brushes are best for you.

3
Painting
Surfaces

Although many surfaces may be painted on, only those widely used with gouache and acrylic will be covered here. **Watercolor Papers** are available in a wide variety of weights, finishes, and shades of white and gray. The following is a general overview of the terms used to describe watercolor paper and its characteristics.

Watercolor paper is commonly available in three finishes, or surface textures, although the degrees of texture on same-named finishes can differ widely from one manufacturer to another. These papers are available in rolls, pads, and individual sheets. Although watercolor paper is intended for use with transparent watercolors, gouache may be used on it with great success; however, it is not recommended for the inexperienced acrylic painter.

Hot Press is the smoothest surface and will take very fine line detail and is used mainly for hard-edged paintings. The surface has very little "tooth" (roughness to the fiber) to hold paint, which has a tendency to lift off the paper at inopportune times.

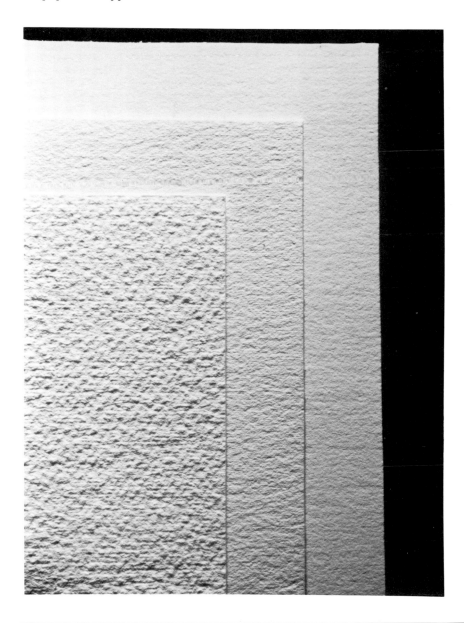

Watercolor paper surfaces. From left to right: *Rough; Cold Press; Hot Press*

Cold Press is the intermediate finish between hot press and rough. With a moderate surface and tooth, it is the finish of choice for the beginning artist.

Rough is, as the name implies, a very rough finish, and because of this is a very difficult surface to work on. It is an attractive surface but does not lend itself well to detailed paintings.

Watercolor paper is listed by weight as well as finish, and if the paper dimensions are the same, the higher weight will be thicker paper. Size is important because the standard is based on how much a ream (500 sheets) weighs, no matter the size. Thus, a larger sheet of the same thickness will be listed at a greater weight.

Most lighter-weight watercolor papers must be stretched prior to use to avoid buckling. This is a simple process. Soak the paper in a pan or tub of water, remove the paper when thoroughly wet, and drain off excess surface water. Then place the wet paper on a flat surface, such as a drawing board, and tape the edges all around using a gummed paper tape. Tack the corners through the tape and let dry. The paper will dry very tight and may be used taped to the board or cut free. Stretching is not necessary with heavy-weight watercolor papers.

Illustration and Watercolor Boards are stiff boards with either illustration paper or watercolor paper adhered to one side. Because of their stiffness, these boards can stand rougher treatment than papers and do not require any prepainting preparation.

Illustration board is lighter in weight than watercolor board and has a slight tendency to warp when large areas are painted. To remedy this problem, merely brush a thin coat of gesso or paint on the reverse side to equalize

The difference in thickness between Illustration Board (left) *and Watercolor Board* (right).

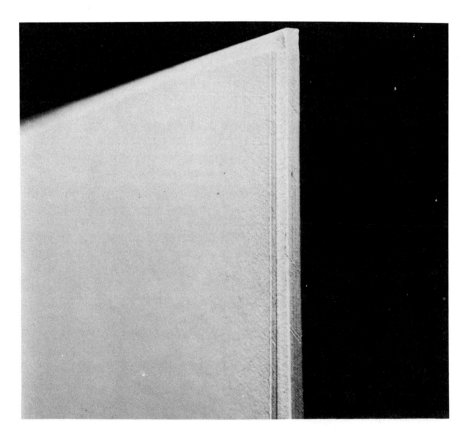

the pull of the paint, thus flattening the board. Illustration boards are available in two surfaces, *hot press* and *cold press*, and the hot press is the smoother and less desirable of the two. Cold press provides good surface for both gouache and acrylic.

Watercolor boards are made with a heavier backing than is illustration board and thus are more resistant to warping. Since the surface is watercolor paper, it responds well to paint. The three surface finishes are the same as those already described for watercolor paper. The preferred watercolor board is Crescent #114 cold press, a very heavy board with Strathmore watercolor paper adhered to it. Gouache and acrylics may be used with great success on this fine board.

Matboards are constructed of tinted paper adhered to stiff backing. There is a temptation to use this board for painting, and it can be done; just be aware that the tinted paper fades to a great degree.

Hardboard, commonly known under the trade name Masonite, is made of compressed wood fibers and is found in tempered and untempered forms. Only the untempered board should be used for painting because the tempered board is impregnated with oil. Prior to painting, the board must be coated with acrylic gesso to provide a suitable ground (surface) for the paint. Preparation with gesso requires rolling or brushing a base coat of thinned gesso, then sanding with a fine sandpaper and dusting and applying more gesso, repeating the process till at least three coats of gesso are on the surface. The reverse side of the board must also be coated but need not be sanded. Gouache may be used on hardboard panels but only with limited success. Acrylics work well on hardboard but it does take some patience, because initially paints go on the slick gesso surface rather irregularly. How-

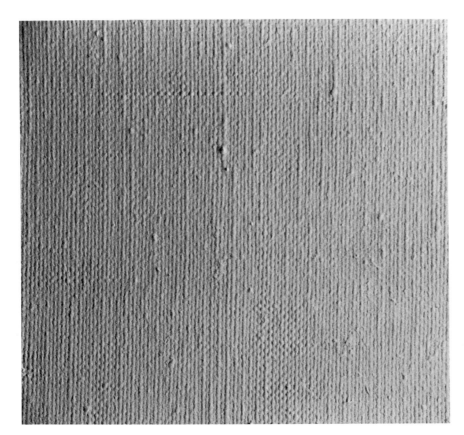

Primed linen canvas

ever, after additional applications of color the painting goes smoothly. A finished acrylic painting on hardboard is very crisp and bright.

Canvas. Both linen and cotton are referred to as canvas and both are available in different grades and weaves, the tighter weaves being the more expensive. Gouache may be used on canvas, but acrylics have much greater success. Because of the inherent texture of the fabric, canvas does not lend itself easily to fine-line paintings—except for the portrait linen canvases.

Cotton canvas is available in several forms: rolls, panels, pads, and prestretched, and the form most suitable for painting with acrylics is the prestretched acrylic-primed canvas. Found in a wide assortment of sizes, these canvases are ready to use and easy to store. The surface of cotton canvas can be rather coarse, with irregularities in the weave.

Linen canvas is more tightly woven, stronger, smoother, and more expensive than cotton canvas, and is available only in rolls or prestretched and primed. The latter is preferred for our purposes. Because of the weave and stability, linen canvas is the preferred choice of most artists because its fine surface permits detailed paintings.

Wood Panels have historically been used for painting surfaces; however, the concern here is not for wood panels but for carved wood used by modern bird carvers. Finished carvings must be primed to accept paint and to provide a white ground that enables colors to be crisp and clear. Wood must first be sealed with clear lacquer or sanding sealer, then one or two coats of acrylic gesso, thinned to the point where it will not fill in carved detail, is brushed onto the surface. When dry, this provides an excellent ground for acrylics. Gouache is not suitable for carvings because of its soft surface.

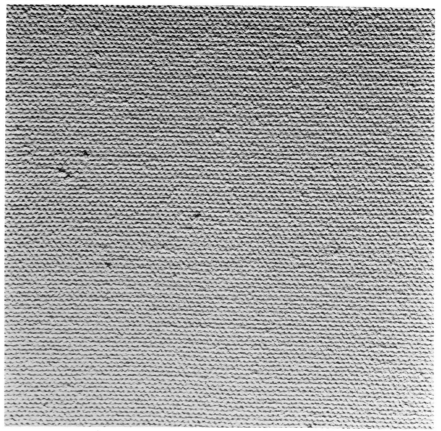

Primed cotton canvas

Additional Media, Tools, and Accessories

Just a peek inside an art-supply store or catalog is enough to bewilder any artist. Besides the array of brushes, paints, and paper, there are myriad accessories and gadgets, some useful—some not. Listed here are only those additional art items necessary for successful bird painting.

Liquid Masking Fluid (Liquid Frisket) is a thin rubber-cementlike fluid that is painted over an area to be left white after painting washes or specific areas. Use a worn out or inexpensive brush to apply the frisket because it dries and balls up in the brush quickly. Immediately after use, wash the brush in water. When the background color is completely dry, the frisket is removed by gently rubbing off with the finger(s) or with the help of a rubber-cement pickup. Liquid frisket is used extensively in bird painting.

Palettes may be made of metal, plastic, paper, china, wood, or glass, in any shape or size, with wells to hold the color or flat, and some have lids to keep the paint moist. Despite the variety available, the best palette is usually the simplest, and anything that will hold paint may be used. Most acrylic painters prefer something that is peelable or disposable like an old plate, pizza pan, or hardboard scrap, and a pan with a shallow lip or enameled tray is ideal for gouache.

Transfer Paper is a thin paper coated on one side with graphite, and it is used to transfer a drawing to a second surface. It is available commercially or may be easily made by first rubbing a thin coat of graphite from a soft pencil or graphite stick on one side of a piece of tracing paper or on the reverse side of a drawing, then smearing the graphite around with a tissue to get a more even coating. To transfer a finished drawing to the painting surface: prepare the back of the drawing as described or place a piece of transfer paper between the drawing and second surface, trace over the lines of the drawing, remove the drawing, and the traced lines are transferred to the painting surface. This acts in the same way as carbon paper does, which, incidentally, should not be used for drawing transfers because carbon paper smears badly and is difficult to erase. If the transfer is to be made onto a dark surface that will not show graphite, smear the back of the drawing with silver- or white-colored pencil instead, and white lines will be transferred.

Brush Washers or *Holders*, as mentioned previously, are handy and inexpensive pieces of equipment.

Water Jars hold the water used for diluting paints and washing brushes while painting. From hand-thrown pots to canning jars, anything that will hold water will do.

Spray Bottles are used for the even prewetting of surfaces. Trigger types are superior to pump types; they may be purchased empty at hardware stores and beauty shops.

Sponges, both natural and artificial, have a variety of surface textures and are used for special effects as well as for controlling water and washes.

Hobby Knives (X-acto types) are used in painting for scratching white lines on painted surfaces and for carefully removing unwanted hairs, paint flakes, or whatever may suddenly appear on a painting.

Tissues, *Paper Towels*, and *Rags* are always handy for removing excess paint or water and for blotting paint from brushes.

Q-Tips provide a ready-made instrument for blotting small areas of paint, as in lifting off (see Techniques).

4
Techniques

 All the basic techniques shown here apply to gouache; however, not all apply to acrylics, because when dry, they cannot be reworked. Though every effort is made to indicate how the techniques are executed, it is difficult, if not impossible, to describe the precise consistency of a paint, wetness of a wash, or amount of pressure on a brush. These are variables that can only be learned through experience. Even veteran artists keep a scrap of board handy while painting to check for consistency, color, load of paint in the brush, or to practice line shapes. Don't be discouraged—these techniques are easy to master through practice. It is important, once you have mastered the techniques, not to overuse them. Learn when to stop.

Flat Opaque Colors—Dilute the paint to a creamy consistency and, using the appropriate-size brush for the area being filled, use broad strokes to fill in with opaque color. Acrylics may require two coats to cover completely.

flat opaque colors

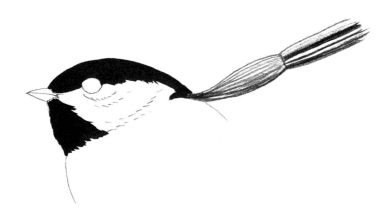

Wet-in-Wet Wash—This technique is used for backgrounds or on the bird painting itself, wherever a continuous, even, transparent color is desired. For a large background wash have a puddle of thinned paint ready to go, then place the board on a slight angle so that the water and then the paint will flow slowly and evenly down the board. Wet the board surface thoroughly so that it shines, then, starting at the top of the board and working downward, brush on the thinned paint from side to side, adding paint and brushing until an even wash is obtained. If the first wash is too thin, wait until it is completely dry and then repeat the process. When working a small area on a bird, wet only the area to be colored and brush carefully. The paint will brush evenly into the premoistened area, giving a beautiful, thin, even coat.

Graded Wet Wash—The preparation is the same as for a wet-in-wet wash; the difference is that the brush is charged with paint only once, and as the brush works down the board there is less and less pigment, thus the

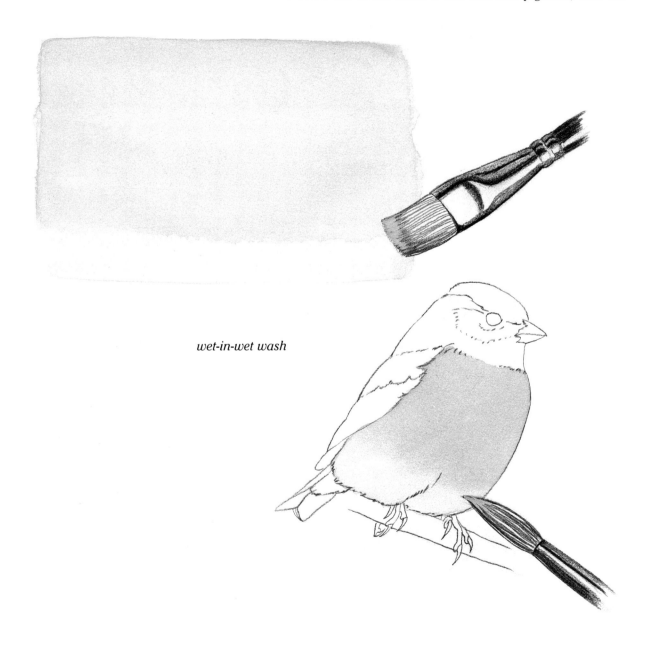

wet-in-wet wash

effect is a graded tone. This is a very useful technique in bird painting, especially for achieving a shaded effect in acrylics by grading a wash over a base color (glazing).

Wet Blending—Paint two areas of color close to each other on a damp surface and work the edges of each color into the other while still wet until a blended effect is achieved. This technique may be used with acrylics but you must plan ahead and work quickly, while the paint is still wet.

Dry Blending—Easily done with gouache but not possible with acrylics, this is, quite simply, blending two adjacent dry colors with a clean, damp brush. Use a light touch on the brush and move it back and forth across the edges of the colors until they are coarsely blended, then brush along the edge to achieve a smooth blend. This is very handy for softening the edges of thin lines, as on wing edges.

Glazing—This is an application of a thin wash of color over an already

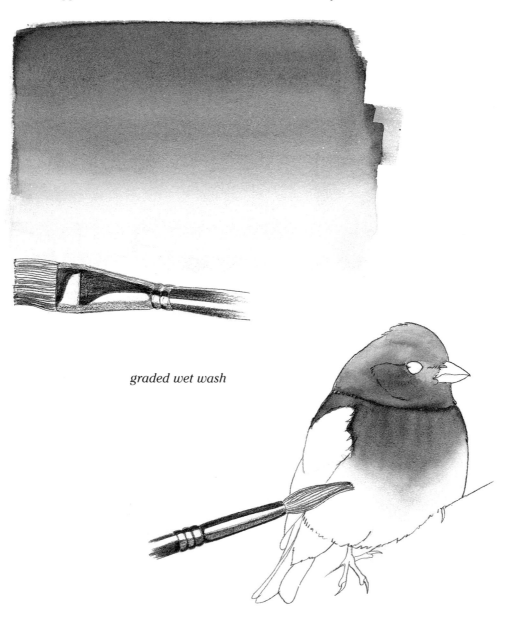

graded wet wash

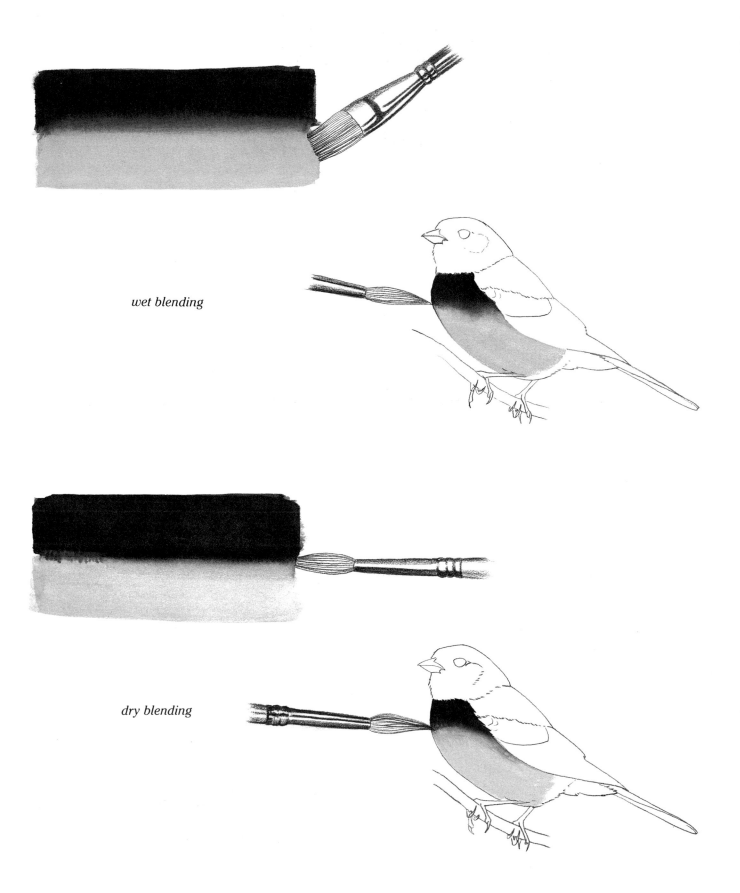

wet blending

dry blending

dry one, allowing the colors to mix. A graded wash painted over a base color is an example of glazing. Acrylics lend themselves beautifully to this technique, but care must be taken with gouache not to overwork the second color on the surface or the colors will bleed together.

Drybrush—Though this technique is rarely used on the bird image itself, it is employed frequently on the supports (twigs, logs, and so on). The brush is charged with color, blotted until almost dry, then dragged across the surface, creating an unpredictable broken, shaded effect. The tip or side of the brush may be used.

glazing

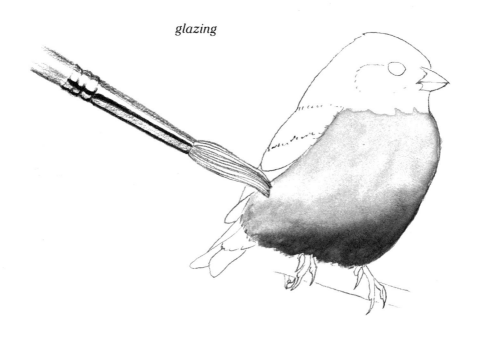

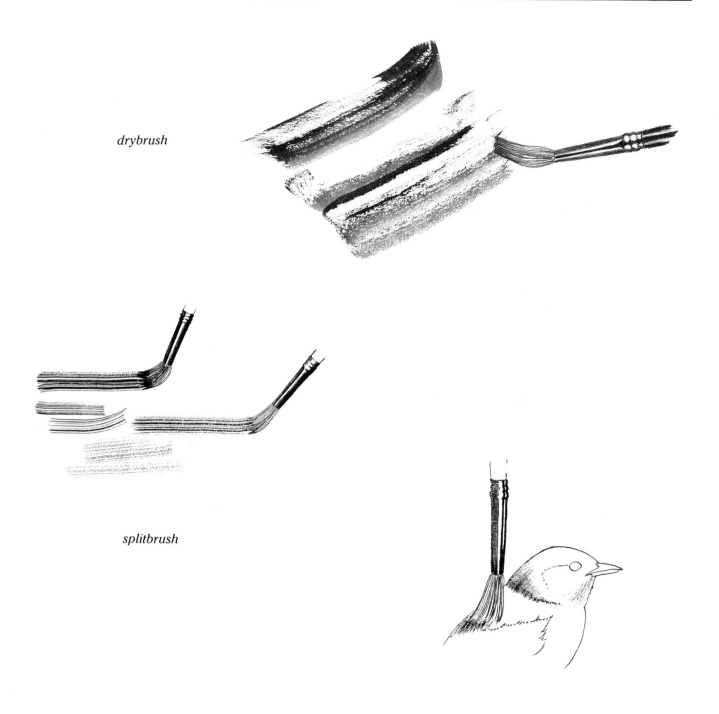

drybrush

splitbrush

Splitbrush—Also known as *heeling* or *feathering*, this is a versatile and fun technique, and one that invites overuse. A round brush is charged with paint and severely pinched or pressed down at the heel (where the hairs and ferrule meet) until the hairs spread apart. Then the tips of the spread hairs are brushed lightly across the surface, making a series of tiny lines. The brush may be blotted to produce drybrush broken lines. A graded or blended effect may be achieved by using a series of light short strokes on the edge of a color. Short light splitbrush strokes are a very effective way to soften the edge of wet acrylic paint, producing a blended effect. Be warned that this is

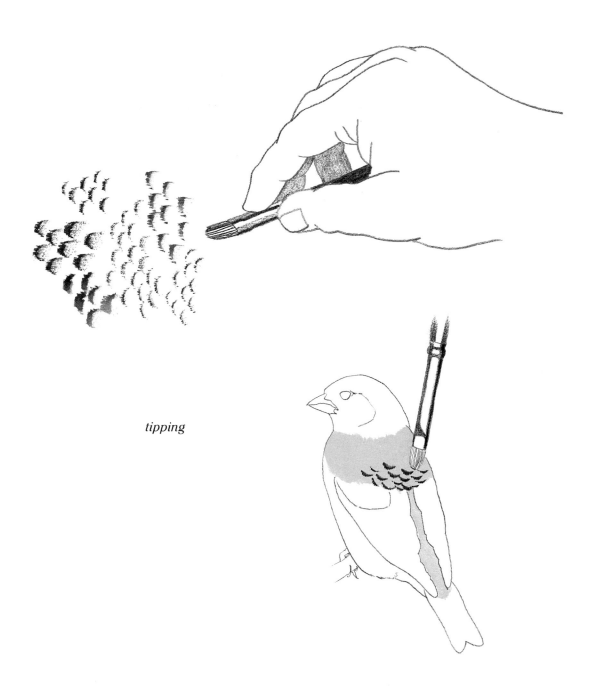

tipping

very hard on brushes; old, worn brushes are recommended.

Tipping—The filbert-shaped brush is most effective for tipping, and care should be taken not to overuse this technique. The brush is not held in the conventional manner, like a pencil, but rather, is held almost parallel to the painting surface, but at a slight angle. The brush is charged with paint and the tip is lightly pressed to and then lifted from the surface. Varying amounts of paint, degree of pressure, or a pressing-then-pulling motion, all produce a wide variety of featherlike marks.

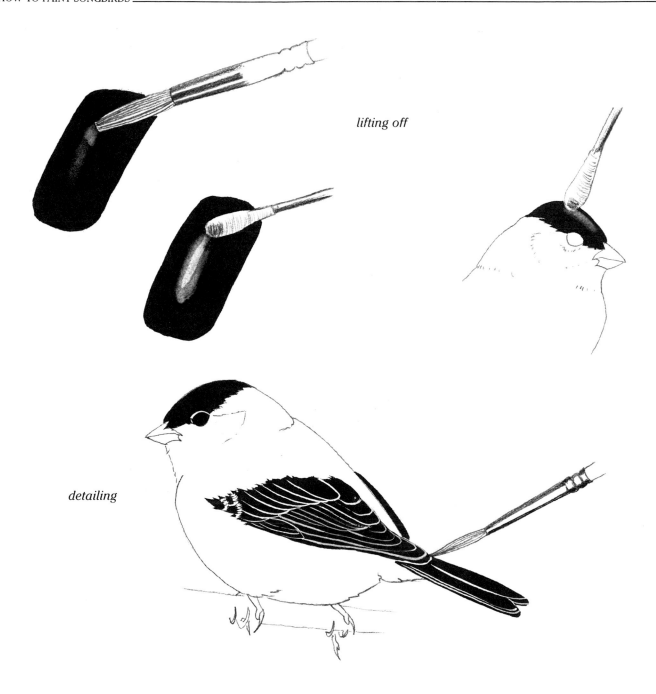

lifting off

detailing

Lifting Off—Rather than adding color to the surface, this is a subtractive technique for removing color (it cannot be done with dry acrylics). A brush filled with clean water is lightly scrubbed over a selected area of dry paint. While the area is still wet, a Q-tip or clean, dry brush is used to lift the loosened pigment from the scrubbed area. This leaves a subtle highlighted area, the shape and size of which is determined by the motion of the wetted brush.

Detailing—Usually the last technique used on a painting, this is the addition of finishing detail, usually employing a small fine-point round brush. In bird painting, the wing edges, highlights, and other finishing touches are described as detailing.

5
Putting the
Techniques Together

 Even though not all the techniques previously described may be used in any one bird painting, many can be. In the following example, transferring and liquid masking are employed along with the painting techniques.

Because the chickadee breast is white, the same color as the painting surface, it was necessary to put on a thin color wash to separate the bird from the background. The painting was done with gouache on cold press watercolor board with a #2 Kolinsky sable round, except for the background wash, which was painted with a 1¹/₂-inch flat wash brush.

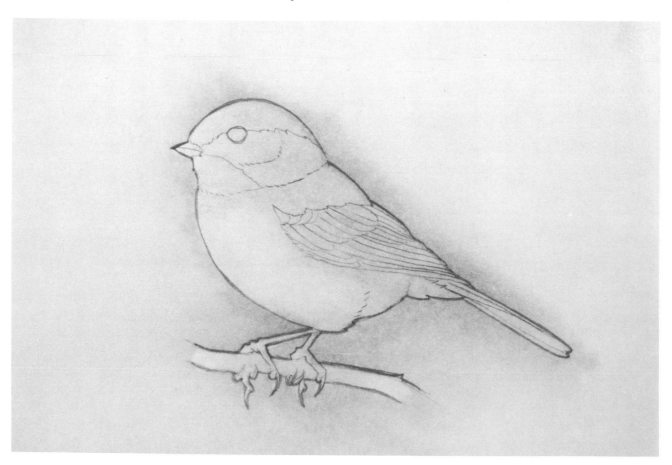

A finished chickadee drawing on tracing paper is prepared for transfer by rubbing the reverse side with graphite.

At this time, only the outline of the bird is transferred to the board and the area to be left white is coated with masking fluid.

The board is moistened thoroughly using a spray mister and the wash brush to spread the water evenly. Then, a thin wet-in-wet wash is applied with the wash brush loaded with thinned paint.

After the wash is completely dry, the masking is rubbed off, revealing the white area of the chickadee to be painted.

The tracing is carefully repositioned over the white area and the major details of the drawing are transferred onto the board.

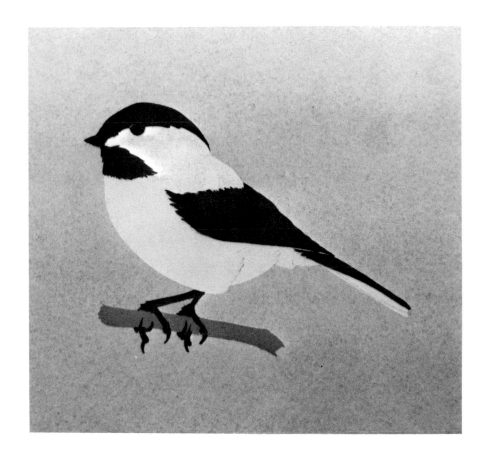

The flat opaque areas are filled in, covering fully the white of the board.

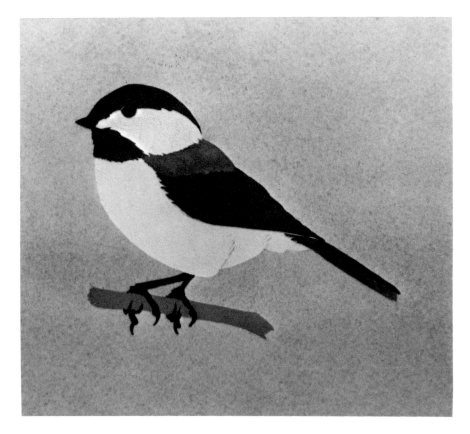

The back and undertail feather areas are moistened and, using diluted pigment, a thin wet-in-wet wash is applied. This gives a lighter look to these areas.

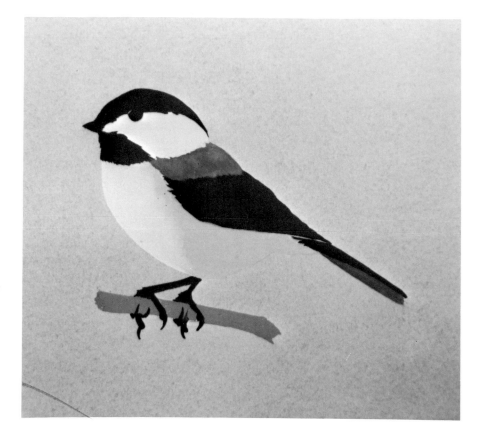

The entire breast, belly, and undertail covert area is moistened well; while wet, color is added to the undertail and belly and worked toward the breast. The brush is cleaned and white is then painted on the breast and worked back toward the belly. The two colors are worked toward each other until they meet and blend. All this must be done quickly, while the board is damp. It may seem difficult but it really isn't.

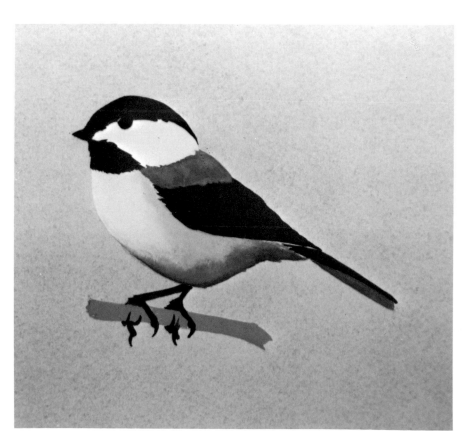

A dark graded wash is glazed over the undertail and belly to add shading and give the bird dimension. It is easiest to accomplish this effect by turning the picture upside down. Load the brush with dark thinned pigment and apply it to the areas that will be darkest. Carefully wash it back and forth, using clean water in the brush until the dark blends perfectly.

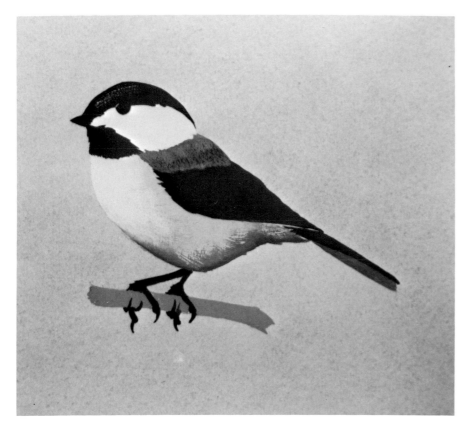

The splitbrush, blotted almost dry, is used to create the illusion of softness and suggest feather groups without actually painting individual feathers, which are not noticeable in the chickadee anyway. The back is brushed with a darker color while the breast is lightly feathered onto the flanks, which in turn are lightly brushed backward. An almost dry brush with a light color is swept across the head to show a highlight on the crown.

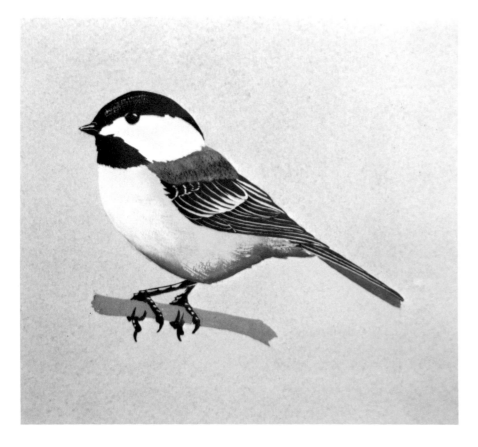

Referring to the drawing for positioning, white details to show feather edges are carefully painted on the wing and tail. If a feather line happens to get out of place, merely go over the area with the opaque color to cover the mistake, and paint the line again. Dilute paint used with a gentle brush touch is used to suggest the scales on the legs and feet. Coarse highlights are painted on the bill and a curved highlight is put on the eye to give the bird life and to indicate the curve of the lens.

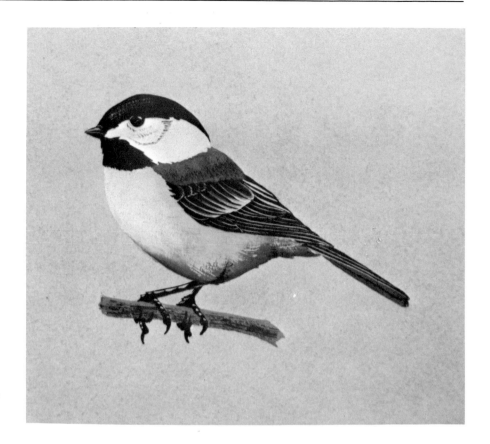

Darker details are added under the tail and at the point where the leg inserts into the body feathers. Detailing is also done to indicate the feathers of the ear patch.

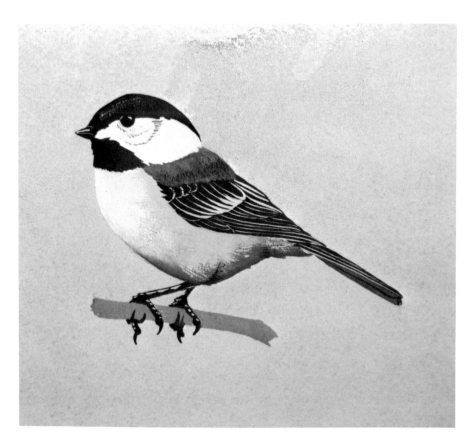

Light drybrushing adds texture to the branch. A clean, moist brush is stroked lightly along the bill highlights and edges of the wing. This softens and blends these areas.

6
Describing Songbirds

Parts of the Bird

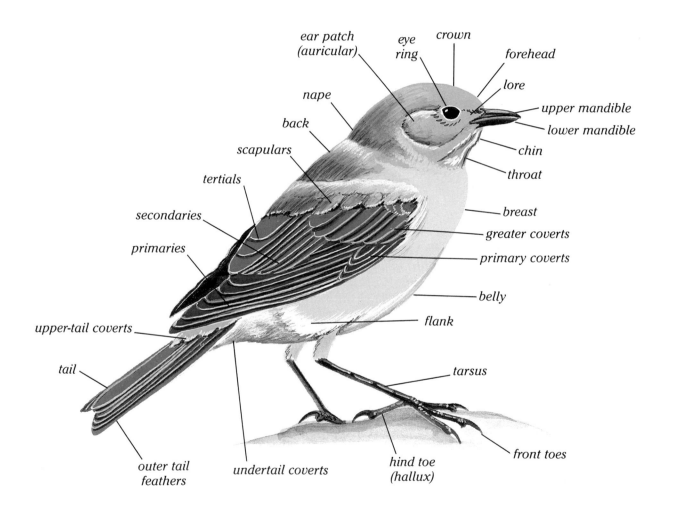

ear patch (auricular)

eye ring

crown

forehead

lore

upper mandible

lower mandible

chin

throat

breast

greater coverts

primary coverts

belly

flank

tarsus

front toes

hind toe (hallux)

undertail coverts

outer tail feathers

tail

upper-tail coverts

primaries

secondaries

tertials

scapulars

back

nape

 A basic knowledge of the parts of the bird and an awareness of the differences that occur between species is essential to successful songbird painting. Not only an understanding of anatomy but of *attitude* will enable you to paint a bird that looks "right." Within the general songbird group there are many physical variables other than the obvious shape and color differences that should be considered. Although many of these features may not appear in a painting, you should be aware that they do occur, and they are an integral part of any bird.

Body Feathers

The body of a bird is covered with feathers that fall into feather groups with specific names. These names will be important as you follow the steps in the painting examples.

Not only do its feathers cover the body of a bird, but they also reflect attitudes. When the bird is relaxed or cold the body feathers are fluffed out. When alert, in fear, or ready to take flight they are tight to the body. These and other feather attitudes alter the contour of the bird. In areas where there are wide seasonal changes some birds grow a greater number of feathers in winter, giving the bird a more plump look. Additionally, seasonal (breeding and nonbreeding) changes greatly affect the colors of some birds.

Feet and Legs

The leg (*tarsus*) in songbirds is covered in one of two ways: smooth or scaled. It should be noted which is the correct form for the particular bird being painted. There are four toes: three pointing forward, and one backward (the *hallux*) in perching birds. Most bird artists have difficulty with the toes and feet, usually depicting the toes grasping the perch tightly in a "death grip." Actually, the toes grip a perch rather loosely. The number of joints in the toes is often misrepresented, and in songbirds the hind toe has no joint at all, thus it cannot wrap around a perch.

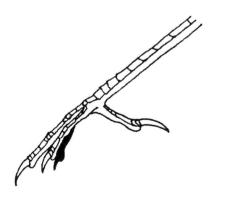
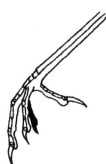

Overlapping Scales *Smooth Scales*

Two Tarsus Types in Songbirds

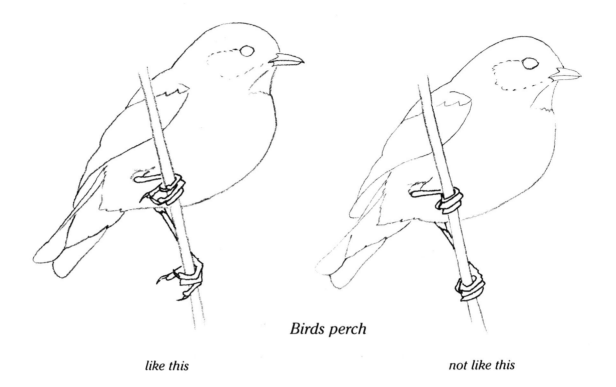

Birds perch

like this not like this

Another problem area for bird artists is finding the proper insertion point where the legs meet the body feathers; if placed improperly the bird looks off-balance. Only careful observation will enable you to paint the feet and legs properly.

Bills

A common error in bird painting where a bird is shown eating or singing is that the artist invariably fails to realize that only the lower mandible moves. The upper mandible cannot move—it is fused to the skull. No matter the shape of the bill, the upper and lower mandibles when closed do not meet exactly on the edges; the lower mandible has a slight curve to the edge that allows it to fit under the upper mandible. When painting the bill, you can show this curve by adding a thin highlight. Also remember that the top of the upper mandible is rounded, not razor sharp.

Though bills come in many shapes and sizes, there is one basic way to paint them. To achieve different shapes, highlights may be added or enhanced. First, the bill is painted in, using opaque color; then the highlights are added, using opaque white; finally, the highlight edges are softened with a clean moist brush.

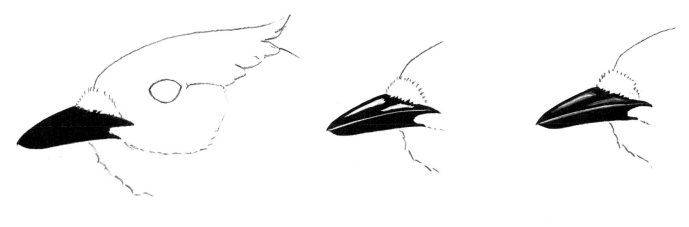

Eyes

A bird's eye is a convex lens, not a flat disc on the side of the head. The lens extends inside the skull as well as out, which means that to accurately portray an eye, depth must be shown by a shaded area at the top of the eye and a highlight that shows the outward curve of the lens. In many songbirds the iris is a very dark brown that is indistinguishable from the black pupil; the eye in this instance appears all black, and curved highlights must suffice to show the roundness of the lens. The pupil must appear in the center of the eye because bird eyes are fixed in the sockets and cannot "roll" as other animal eyes do. A bird eye is not round but slightly elliptical.

To paint a realistic bird eye, a thin iris color is first painted over the entire eye. Then, opaque black is painted at the top of the eye to indicate shadow, and the iris is placed in. After the black is dry, a clean moist brush is used to dry-blend the shadow area downward. Finally, the curved highlight is added carefully with opaque white.

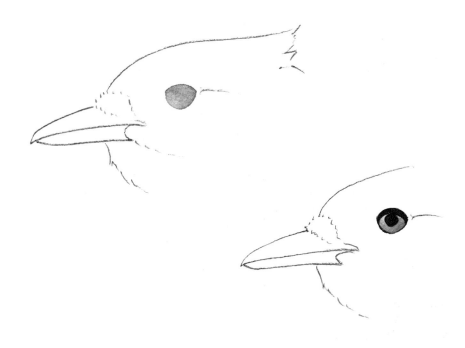

continued next page

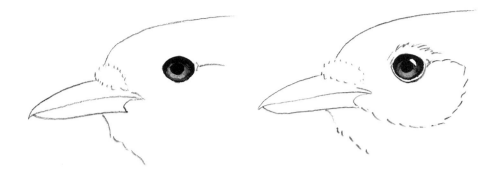

Wings

Note that the features of the wing have specific names. Also notice the direction in which the feathers overlap one another—this direction is consistent. The primaries and secondaries are easily counted and may vary in number between species; however, this is only of major concern when depicting flight because when the bird is at rest the feathers are tucked and not all are visible. The coverts, on the other hand, are small and because of color and ill-defined edges are difficult to count; they are usually painted as a group.

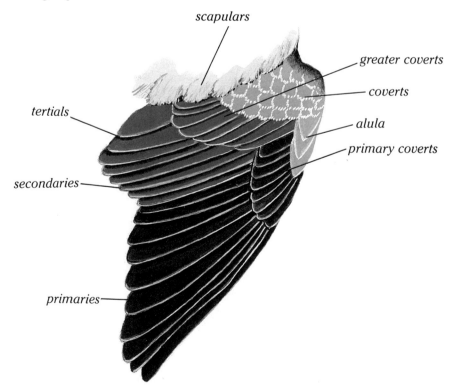

Parts of the Wing

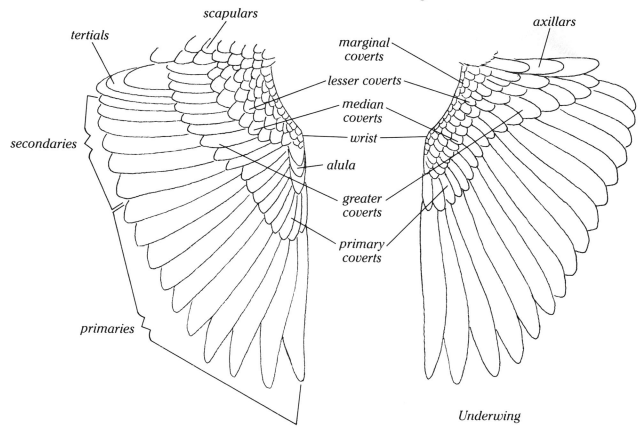

tertials

scapulars

marginal coverts

axillars

lesser coverts

median coverts

wrist

secondaries

alula

greater coverts

primary coverts

primaries

Upper Wing

Underwing

The Underwing coverts are known collectively as the "lining."

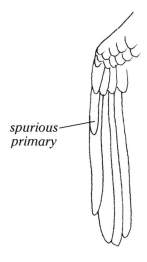

spurious primary

Underwing

Some songbirds have a modified first primary.

It is very important to know how the wing folds because the covering of various feather groups by others when the wing is folded determines which feathers are visible. Notice how, as the wing folds, only the edges of the secondaries are seen and not all primaries are visible. The greater coverts and some primary coverts are the only other wing feathers exposed in a tightly folded wing.

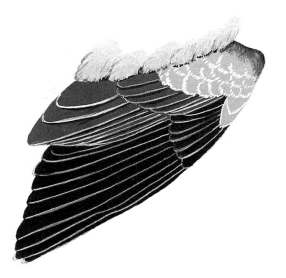

How the Wing Folds

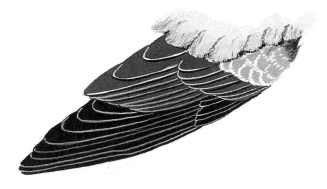

Painting a primary feather. The illustration shows not only the fundamentals of painting a large primary, but the shading indicates that the feather has *camber* (curvature), which is essential to flight.

To paint: The front of the feather (above the shaft) is given an even coat of color. The back of the feather is dampened thoroughly and a graded wash is applied, working from the shaft down. Then, the splitbrush technique is used to indicate feather barbs. Last, surface color is painted back into the feather to indicate breaks that occur between the barbs.

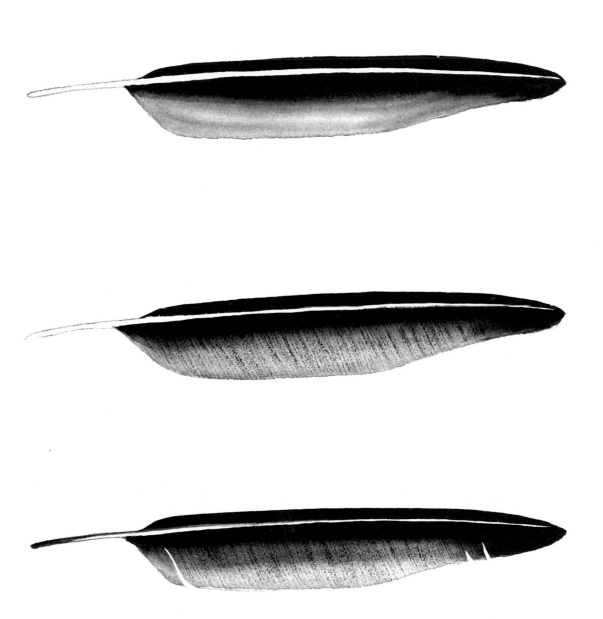

Tail

The shape and number of feathers in the tail is variable, and the end contour of the feathers may range from rounded to flat to forked. It is important to remember when rendering the tail that it is not flat but curved, with the center feathers being higher than the outer ones. While an important element in flight, the tail also acts as a balancing feature in perching birds, and may be tilted at odd angles for birds to maintain their perch when landing or during heavy winds. It may also reflect behavioral attitudes of many species; for instance, when a wren is excited the tail points up, while when in full song the tail points down. Thus not only the specific shape of the tail but its typical attitude for a species should be portrayed correctly.

Though the number of feathers may vary, the way they overlap is consistent. Notice in the illustration that there is not one but two central tail feathers.

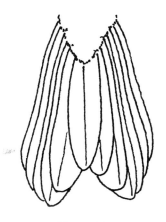

Upper Tail

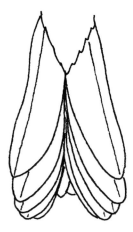

Undertail

7
Painting
Examples

Random Notes Prior to Painting

As you follow along with the painting examples, you will notice that at times certain adjustments are made to the picture in color, value, shape, or whatever. This is the way a picture actually progresses; changes are always being made. These examples were not prepainted and then done again for this book. These are first-time examples, done so that you could see the real process of a bird picture being painted, corrections and all. Very little may be learned from watching the painting of a flawless picture.

Plan ahead when beginning a painting; have only those brushes, colors, and materials you will need at hand. Excess tubes, brushes, and whatever only add clutter when you need it least. Although the colors on your palette initially look organized when first squeezed out, don't be dismayed when it all seems a mess after a short time. Very few artists maintain a controlled palette. Have a scrap of watercolor board handy to test brushes for load and stroke, and a rag or paper towel to blot brushes. Give yourself clean water, brushes, all the other painting stuff you'll need, and time to paint.

The following painting examples were done on cold press illustration board and the paints are gouache (designers colors). Winsor & Newton and Pelikan brands are used interchangeably, except in the case of raw umber, where the brand used will be noted. Pelikan raw umber has less yellow than does Winsor & Newton raw umber. All painting examples are larger than life-size.

Black-Capped Chickadee

Parus atricapillus

With a black cap covering the head and hiding their eyes, chickadees look like tiny bandits, and, indeed, they act like bandits. Fearless, they strike in broad daylight, flitting in to steal a seed from the feeder or right from the hand, and then back out into the trees. Their coloration, size, and antics make them one of the most recognizable and popular of our birds. Initially, the chickadee appears black and white; however, upon closer examination, subtle shades of gray and rusty brown become evident. The challenge for the artist in painting a chickadee is twofold: to capture not only the pattern and color, but attitude and personality.

As you follow the steps in this painting example, you will notice that other techniques are used than those in the chickadee in the techniques section. This is done to show the variety of techniques that may be employed to achieve a similar effect.

The palette used is: lamp black, white, yellow ochre, burnt umber, Payne's gray, and Pelikan brand raw umber. The brushes used are #3 and #1 Kolinsky sable rounds. Unless specifically noted, the #3 round is the brush used.

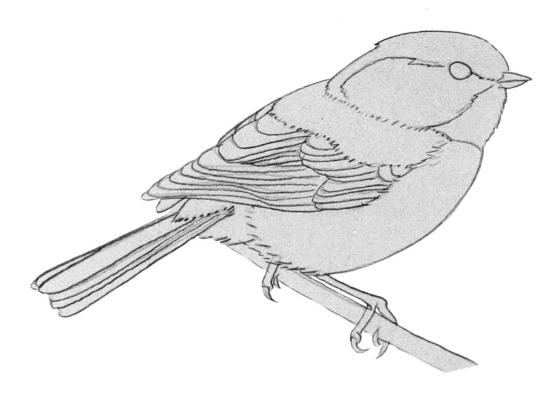

The completed chickadee drawing is transferred to the board.

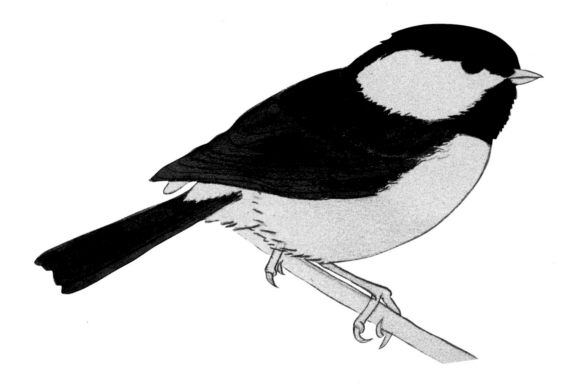

Opaque black is painted on the eye, crown, and throat. Black is then thinned considerably and carefully washed, wet-in-wet, over the wing and tail. Payne's gray and raw umber are mixed and thinned slightly, then painted over the back and scapulars, which, incidentally, are virtually indistinguishable from each other in the chickadee.

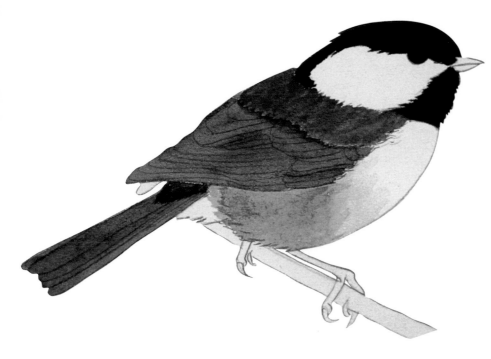

The same mixture of Payne's gray and raw umber is used on the upper-tail coverts. Yellow ochre, burnt umber, and raw umber are mixed and thinned slightly, the picture is turned upside down, and, starting at the back of the flank, a graded wash in the above mixture is worked toward the breast.

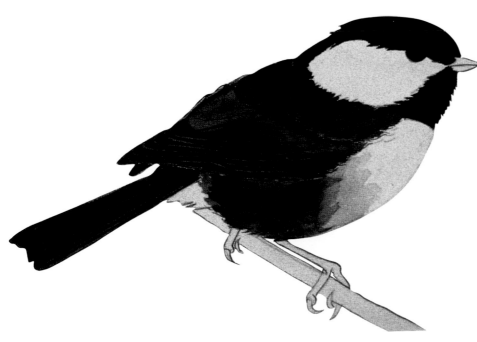

A #1 round is used with lightly thinned black to paint over all the wing feathers, except the tertials and secondary coverts. Be careful to leave a thin line of the black base color on the edge of each feather. The same thing is repeated on the tail feathers. The black pencil line on the breast is erased. Additionally, opaque black is used to darken and separate the far wing.

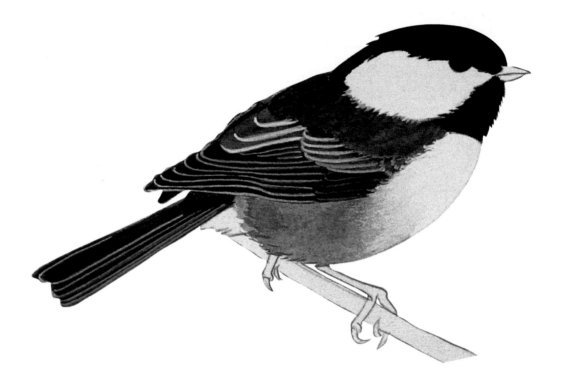

Pure white is painted on the cheek, undertail coverts, and breast. To achieve a softer edge between the white and flank color, the splitbrush is used to lightly brush opaque white over the transition area (this is a technique used effectively with acrylics). The #1 round is used to line the wing and tail-feather edges with white, except for the primary coverts.

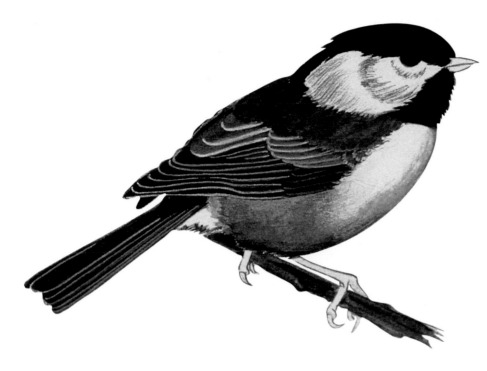

The white edges of the tertials and secondary coverts are softened by drawing a clean, damp brush along the edge of the white. Again, the painting is turned upside down and very dilute black is washed on the belly and up the breast. Then, this black is pulled carefully back into the body with a clean, moist brush. If, initially, the shaded area does not appear dark enough, let it dry and repeat the process. Dilute black is then painted on the undertail coverts and a splitbrush is again used on the nape and ear patch. Gentle, light strokes are employed here. The branch is painted with raw umber, thinned slightly.

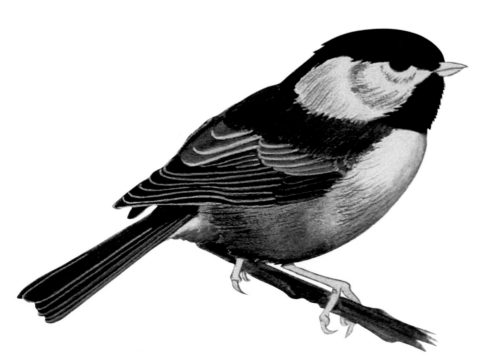

Opaque black is used with the split-brush on the back area, and very dilute black is splitbrushed on the breast to suggest feathers. The same technique is used with raw umber on the flanks. With a clean, moist brush, the black on the undertail coverts is softened and blended.

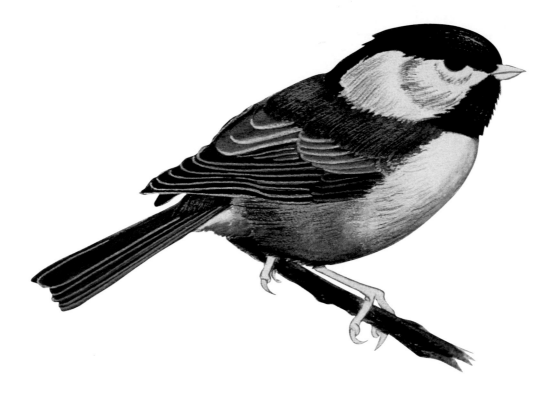

The black splitbrush on the breast looked overdone, so opaque white was used, again with the splitbrush, to go over this area, covering some of the black to give a softer look. White and raw umber are mixed and used rather thickly with the splitbrush on the back and upper-tail coverts to add highlights to those areas. Drybrush opaque white is used lightly on the head and throat, again to add highlights, and black is drybrushed on the branch to suggest shadow and texture.

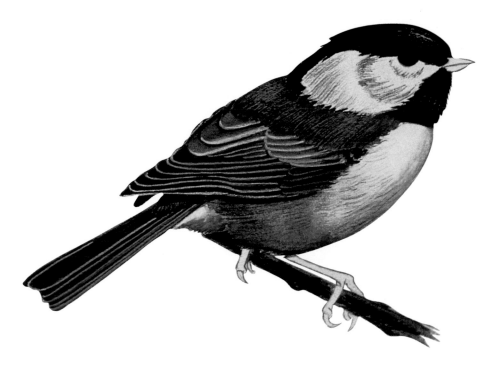

Using the #1 round, opaque black is carefully painted along the edge where the white nape meets the back, under the upper-tail coverts (to separate them from the tail), and where the wing inserts into the body feathers. A larger black line is then painted under the wing and the bottom edge of this line is softened with a clean, damp brush. This separates the wing from the body. All this black detailing serves to give definition to specific areas.

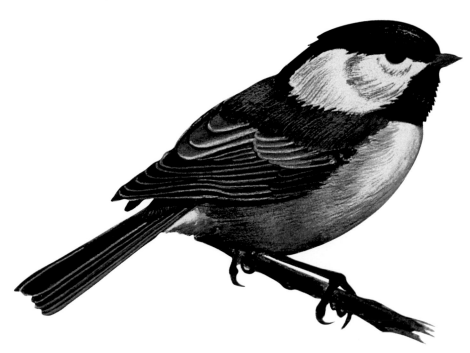

Dilute black is painted on the bill, feet, and legs and is also washed over the white edges of the primaries, which were too white. The flank color (raw umber, yellow ochre, and burnt umber) is used with the splitbrush to bring this rusty color up the back edge of the breast. It is painted over the white to achieve a cleaner, more feathered look than if it had been painted at the same time as were the flanks.

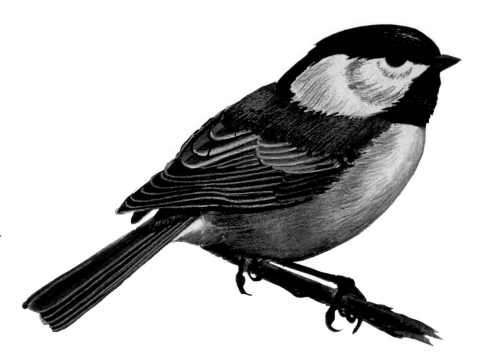

The white edges on the tail are soft-ened. The #1 round is used to paint a thin, hard black line under each tail feather and a tiny vane down the main tail feather and the tertials. Opaque black is also used to rough in the bill and leg-shadow areas. Tiny black shadows are painted under the scapulars to separate them more from the wing.

Very dilute white is used with the #1 round to carefully paint in light bill highlights and dab in the scales on the toes. Since the top of the eye is virtually indistinguishable from the black cap, a little artistic license is employed here and a tiny light line is painted at the top of the eye to separate it from the black cap.

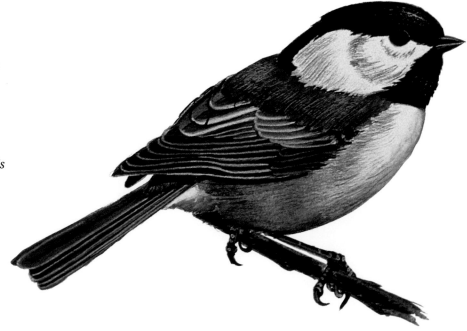

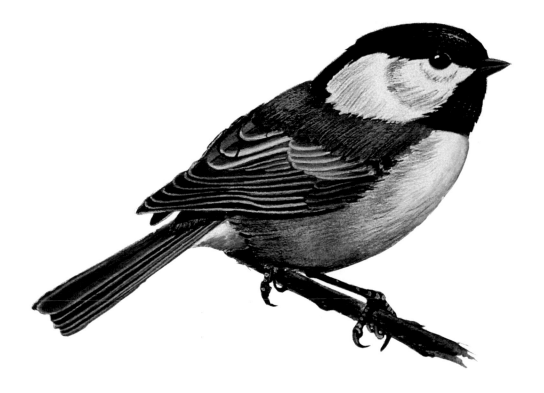

With a clean, damp brush the white and black on the bill are blended. Opaque black is used to further define the shadow areas on the leg and feet. Tiny black lines are painted at the back of the flank to separate it more from the undertail, and the curved opaque white highlight in the eye gives the finished chickadee life.

Cedar Waxwing

Bombycilla cedrorum

One of the more common songbirds, cedar waxwings are frequently seen traveling in small flocks, feeding on ripe fruits and berries. They move in and out of areas quickly, making their comings and goings unpredictable. They don't have much of a song, but what they lack in voice they make up for in beauty. Subtle browns, yellows, and grays, with the red wax-like tips on the secondaries and yellow tips on the tail feathers make this bird distinctive. It has a smooth, almost silky look with very little feather definition and this presents a temptation to the artist to overpaint the feathers, adding more detail than actually appears in nature. The key to successfully painting a waxwing is not only to accurately depict the colors and attitude, but to capture its soft, almost sculptural, quality. To achieve this effect, the split-brush technique is used extensively.

The palette for this painting consists of: raw umber (Winsor & Newton), Vandyke brown, white, cadmium yellow pale, cadmium red pale, Payne's gray, ivory black, yellow ochre, and burnt sienna. The brushes used are Kolinsky sable #3 and #1 rounds. Unless specifically noted, the #3 round is the brush used.

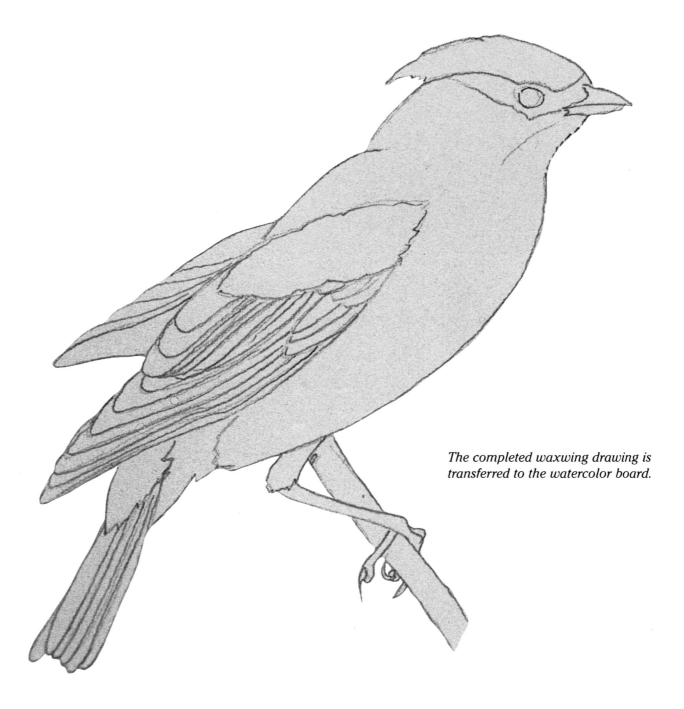

The completed waxwing drawing is transferred to the watercolor board.

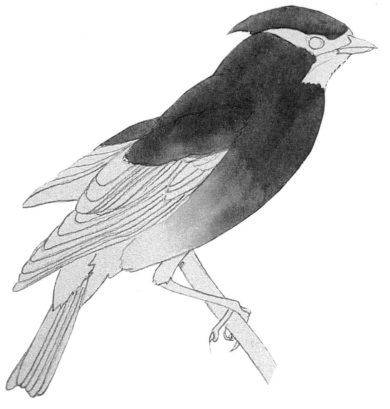

Vandyke brown, raw umber, and a small amount of white are mixed for the basic body color and thinned considerably. The areas to be painted with this mixture are moistened well with clear water, then the head, scapulars, and back are evenly painted, wet-in-wet, quickly working toward the top of the breast, which is painted from the top down. Replacing pigment in the brush with clean water, the base color is graded to clear as the wash is brushed down the belly.

Cadmium yellow pale and white are mixed and thinned. The picture is turned upside down and, starting on the flank, the yellow-white is brushed toward the breast, using less and less pigment and more water until a good blend is achieved. If, initially, the yellow-white is too pale or if the blend is not good, let the paint dry completely and repeat the process. Additionally, opaque white is painted on the undertail coverts and at the base of the bill between the throat and eye areas.

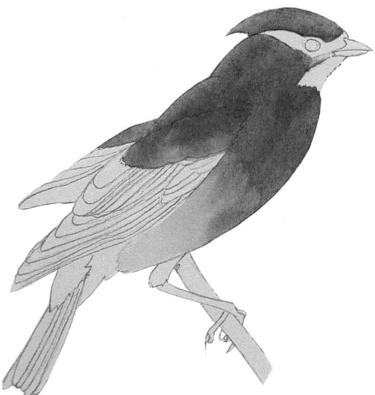

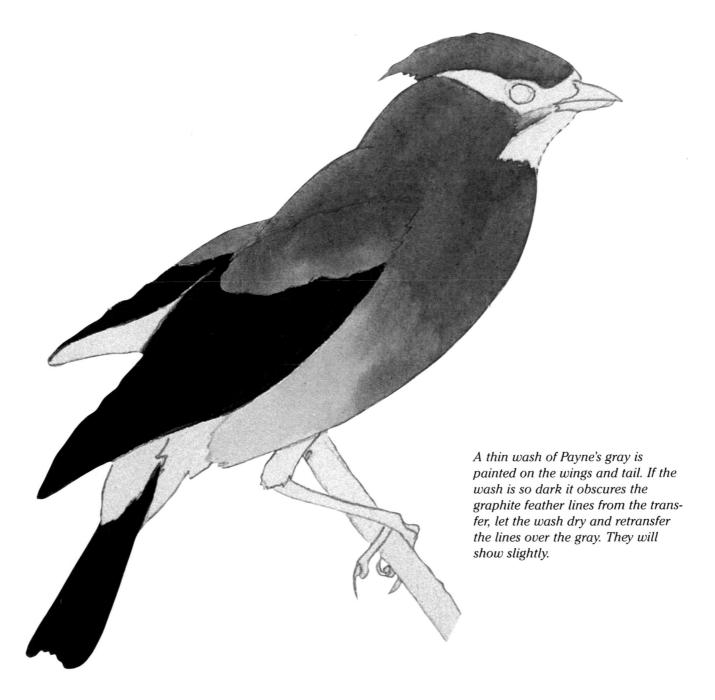

A thin wash of Payne's gray is painted on the wings and tail. If the wash is so dark it obscures the graphite feather lines from the transfer, let the wash dry and retransfer the lines over the gray. They will show slightly.

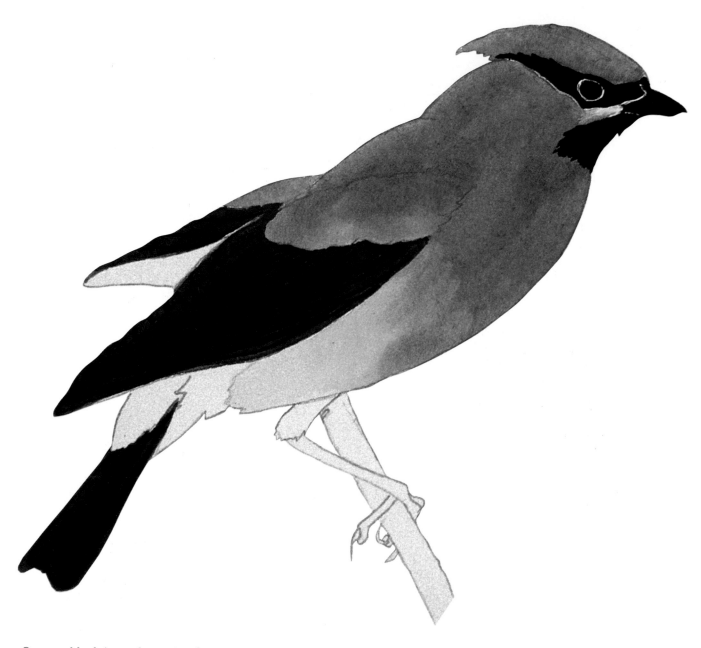

Opaque black is used to paint the throat, bill, eye, and band around the head. It is also used with the #1 round to delineate the shadow below each feather edge on the wings and tail.

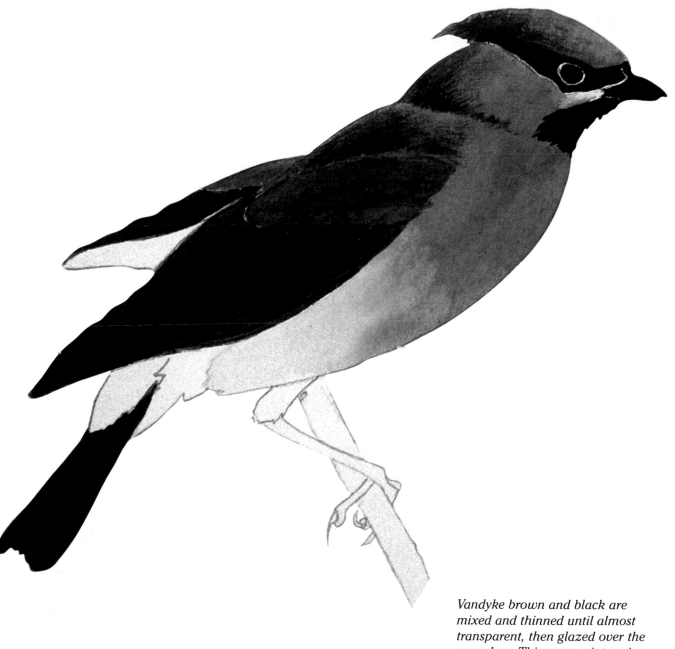

Vandyke brown and black are mixed and thinned until almost transparent, then glazed over the scapulars. This same mixture is used with a splitbrush on the back, nape, and crest. If the glazing or splitbrush painting does not appear dark enough at first, let the painting dry and gradually add more thinned color until the desired density is achieved.

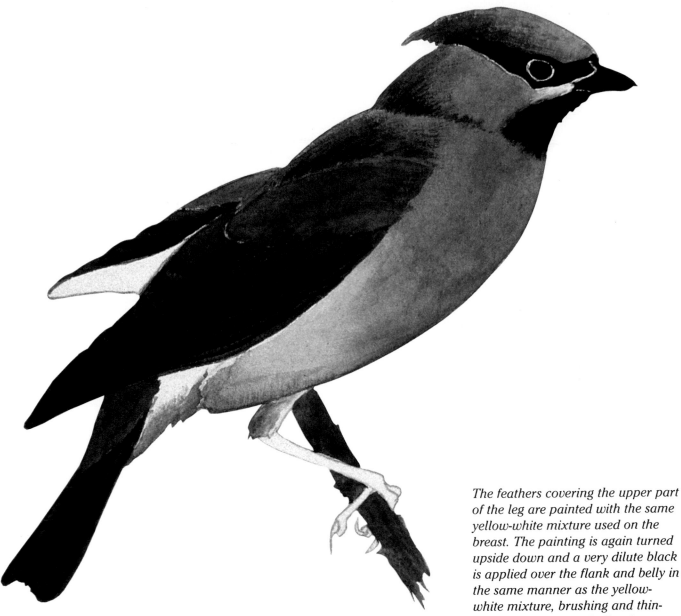

The feathers covering the upper part of the leg are painted with the same yellow-white mixture used on the breast. The painting is again turned upside down and a very dilute black is applied over the flank and belly in the same manner as the yellow-white mixture, brushing and thinning until the shaded effect is achieved. Don't panic if the black appears too dark when wet; it will dry lighter. The dilute black is also shaded onto the leg and undertail coverts. The bottom edges of the black feather lines on the wing and tail are softened by brushing gently with a clean, moist brush. The same technique is used on the edges of the throat. Payne's gray mixed with white is painted opaquely on the upper-tail coverts, and the branch is blocked in with a mixture of raw umber and burnt sienna.

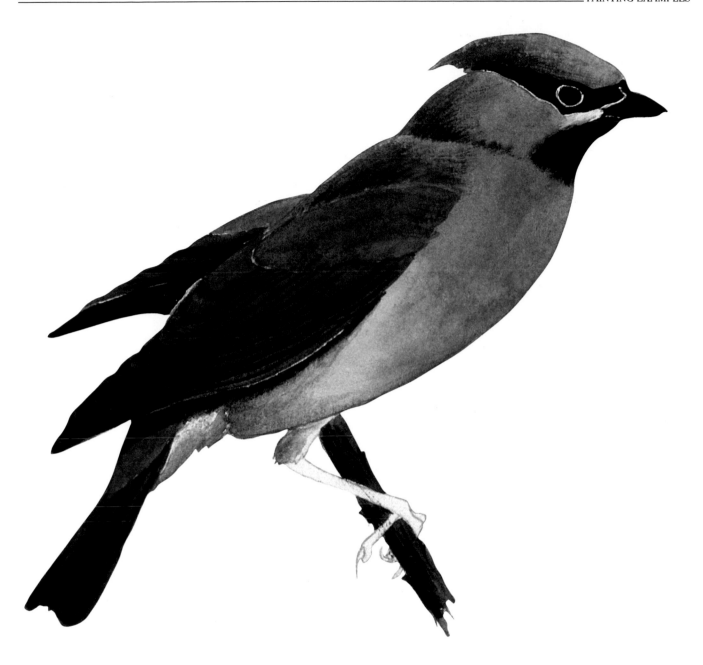

Opaque black is painted under the far wing and along the body under the near wing. The bottom of the black line under the near wing is then softened and blended into the body, using a clean, moist brush. Notice how this shadow area pulls the wing away from the body and gives roundness to the body at the same time. Additionally, black is drybrushed along the branch to add texture and shading.

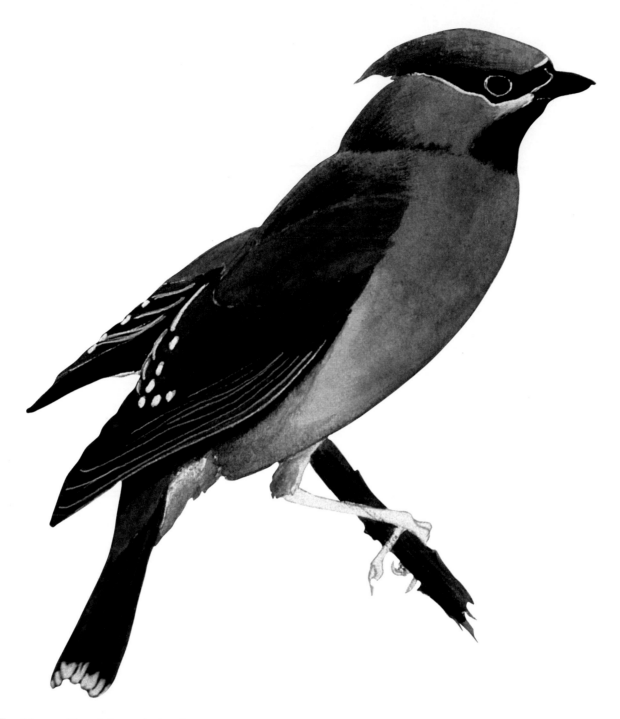

The #1 round brush is used to paint the white edging on the primaries and the white on the inside edges of the tertials and secondaries. Opaque white is carefully added to the spots where the red "wax" will be painted and also to the tail-feather tips, which will be yellow. The white gives a good reflective base for the red and yellow.

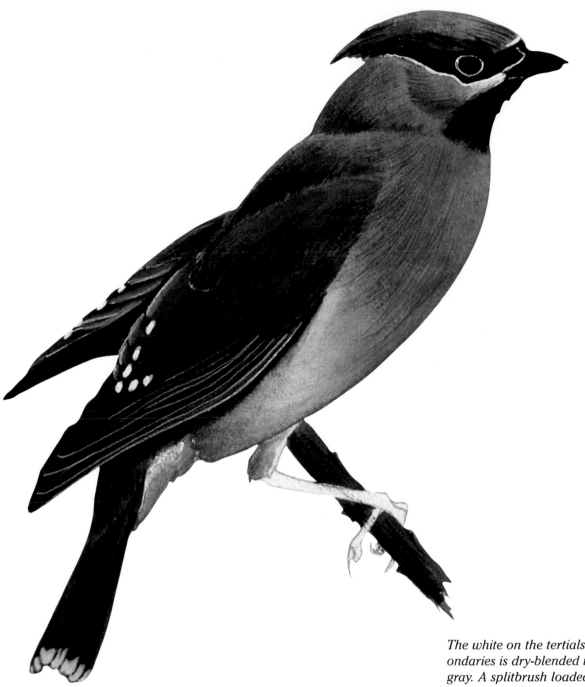

The white on the tertials and secondaries is dry-blended into the gray. A splitbrush loaded with thinned Vandyke brown is lightly brushed on the scapulars, nape, and back (areas darkened before with a base color). This adds color, definition, and softens the hard edges. The same technique and color are used to add feather detail to the breast and define the ear patch. The splitbrush is now loaded with Payne's gray and brushed over the upper-tail coverts.

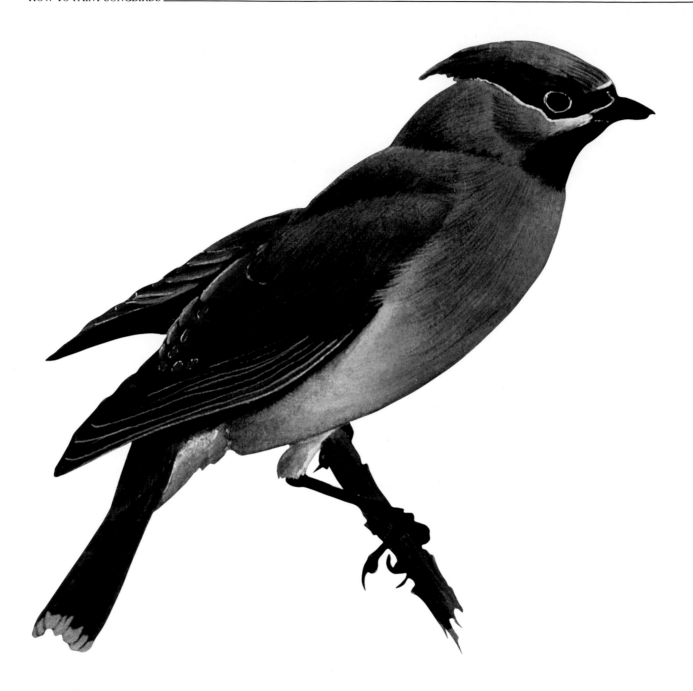

Opaque cadmium red pale is
dabbed on the white spots on the
secondaries, and cadmium yellow
pale is painted over the white on the
tail tips. Black fills in the legs and
feet. Yellow ochre, Vandyke brown,
and white are mixed, thinned only
slightly, and used with a splitbrush
to lightly paint highlights on the top
of the scapulars, back, and breast,
and to show small breast feathers
overlapping the wing.

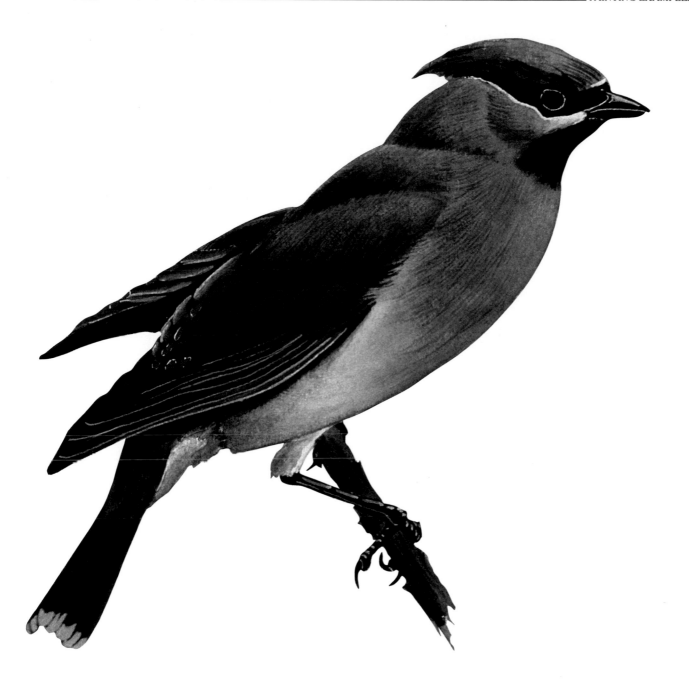

A splitbrush loaded with black is used to soften the bottom edges of the scapulars where they cover the top of the wing. The #1 round brush is used with black to darken the wing where the breast feathers overlap it and to tighten up the area around the eye. Thinned white is then used to lightly paint the scales on the leg and toes. White is again used to roughly indicate the highlights on the bill.

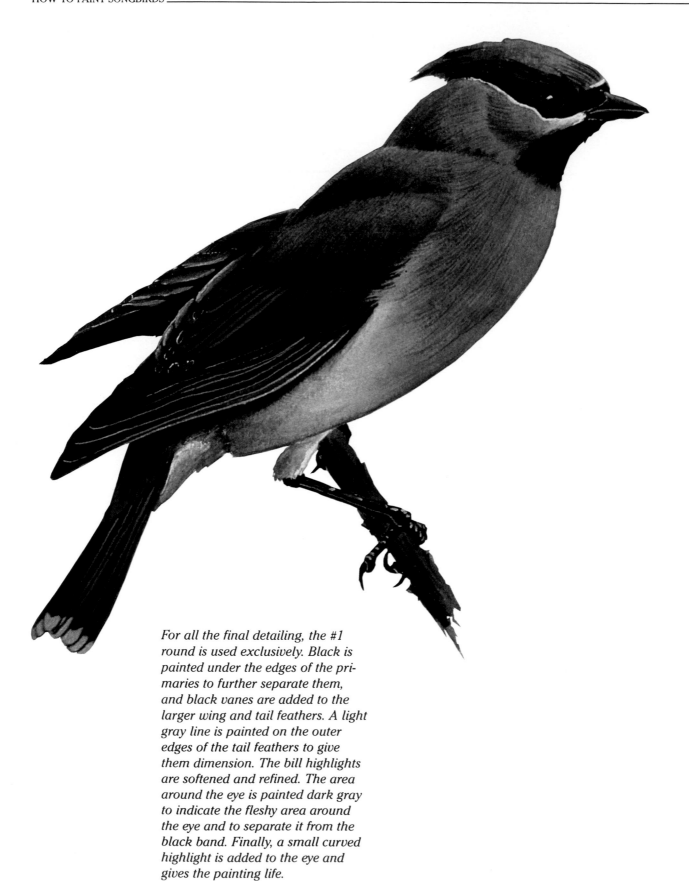

For all the final detailing, the #1 round is used exclusively. Black is painted under the edges of the primaries to further separate them, and black vanes are added to the larger wing and tail feathers. A light gray line is painted on the outer edges of the tail feathers to give them dimension. The bill highlights are softened and refined. The area around the eye is painted dark gray to indicate the fleshy area around the eye and to separate it from the black band. Finally, a small curved highlight is added to the eye and gives the painting life.

Eastern Meadowlark

Sturnella magna

Commonly seen in fields and meadows, bright color and unique markings make this bird unmistakable. A brilliant yellow breast with a black bib and brown back—it could only be a meadowlark. Not only do its colors and patterns make it distinctive, but a short tail, robust pointed bill, and very long claw on the hind toe contribute to the meadowlark's singular appearance. It would seem that, by combining all of these unique characteristics, this would be an easy bird to paint; however, this is not the case. To make a believable bird, all of the colors and patterns, though separate, must be painted so that they blend together, not as a puzzle of parts stuck on.

Though there are two meadowlarks, the eastern and the western, the only differences between the two are that in the western the yellow on the throat extends slightly farther up the cheek, and the back is a lighter brown.

The palette for the meadowlark consists of: white, ivory black, yellow ochre, ultramarine blue pale, burnt umber, raw umber (Pelikan brand), cadmium yellow middle, and violet lake, which is the complementary color of yellow. Complementary colors (the opposite of a color on the color wheel) when mixed have a neutralizing or graying effect on one another. The brushes used are #1 and #3 Kolinsky sable rounds. Unless noted otherwise, the #3 round is the brush used.

Painting examples begin on following page.

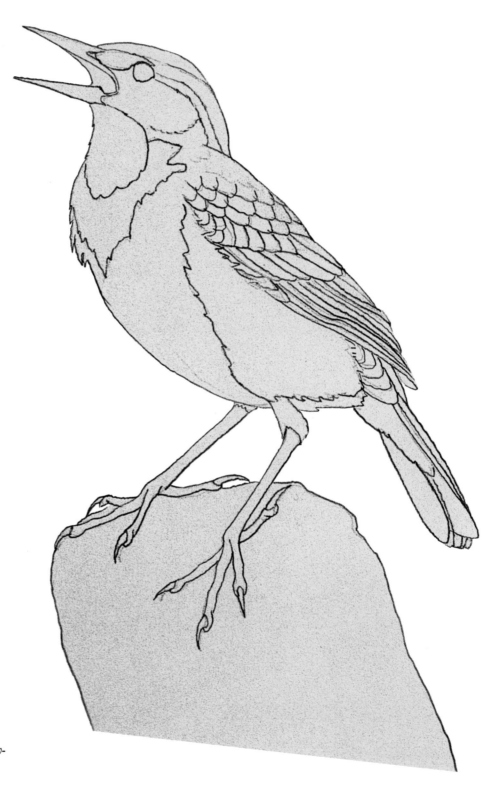

The completed meadowlark drawing is transferred to the board.

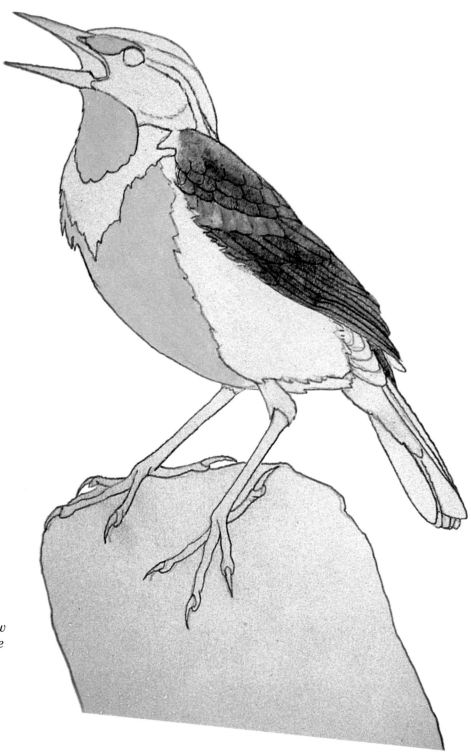

A thin wet-in-wet wash of raw umber is painted over the back, scapulars, and wing, and cadmium yellow middle is washed, wet-in-wet, on the breast, lore, and throat. After the raw umber and yellow are dry, opaque white is painted over the flanks, head, and undertail coverts. Additionally, a very thin wash of white is applied over the brown on the wing coverts.

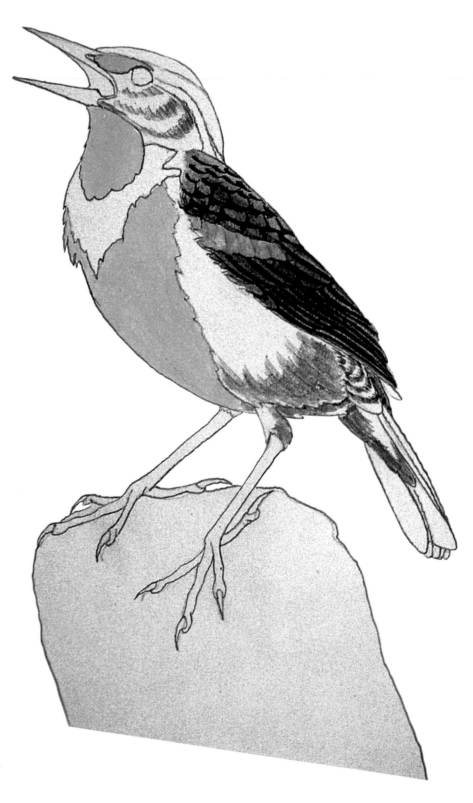

A very dilute mixture of raw umber and black is lightly splitbrushed on the undertail coverts, upper leg, and flank, and small, short strokes with the same mixture are used to define the ear patch. The #1 round is filled with opaque raw umber and used to underline all the wing and back feathers. The bottoms of these lines are then softened individually with a clean, moist brush.

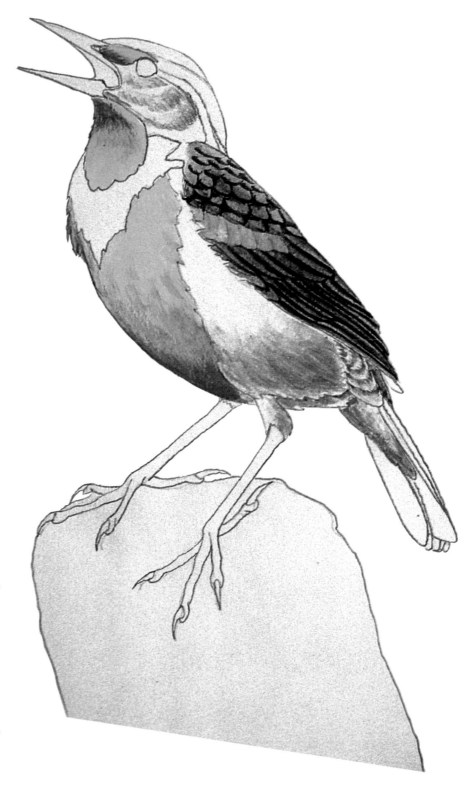

The hard edges of the raw umber and black mixture just painted on the undertail coverts, flanks, and leg are softened and blended into the white. Cadmium yellow middle is mixed with a tiny amount of violet lake (complementary colors) and splitbrushed to shade the yellow areas. The shading is added slowly until the desired density is achieved. The hue achieved by mixing these colors is very different from just mixing black with the yellow, which would not result in such a rich shadow color.

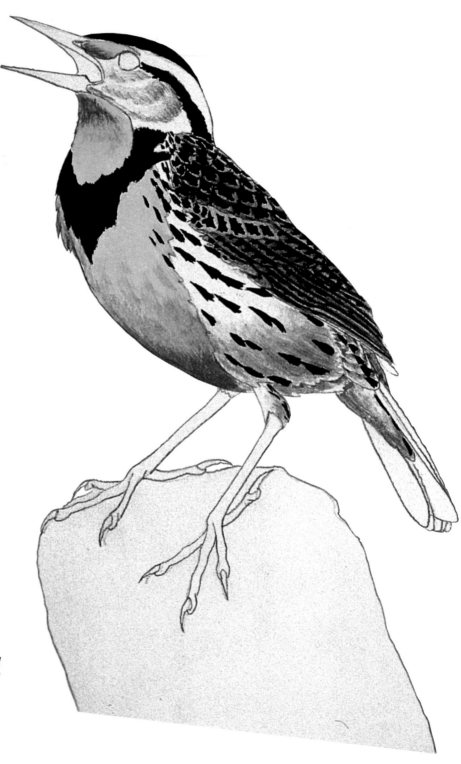

Opaque black is used to paint the breast and head, and to carefully fill in the patterns on the scapulars and wings. The markings on the sides and flanks are also painted with black. Care must be taken to curve these marks to follow the contours of the body.

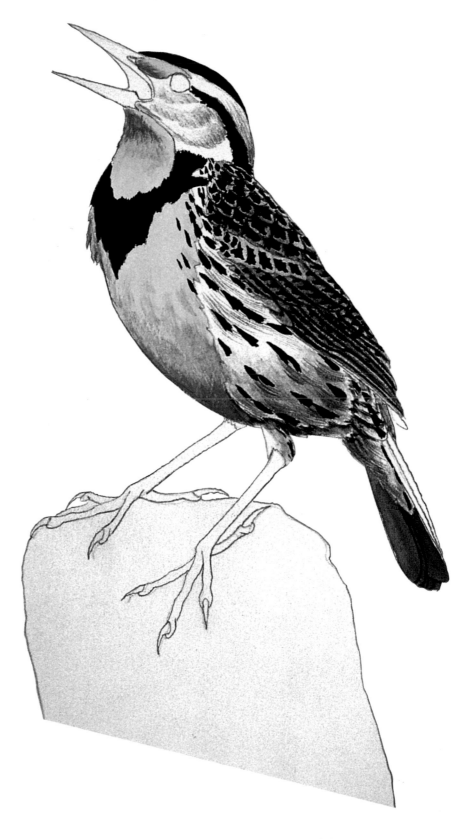

White and black are mixed to a medium gray and applied opaquely to the underside of the tail feathers. The edges of these tail feathers are then detailed with black. Short, light strokes with the splitbrush are then used to brush very dilute black on the nape, undertail coverts, and then on the flank to indicate light feathering and shading.

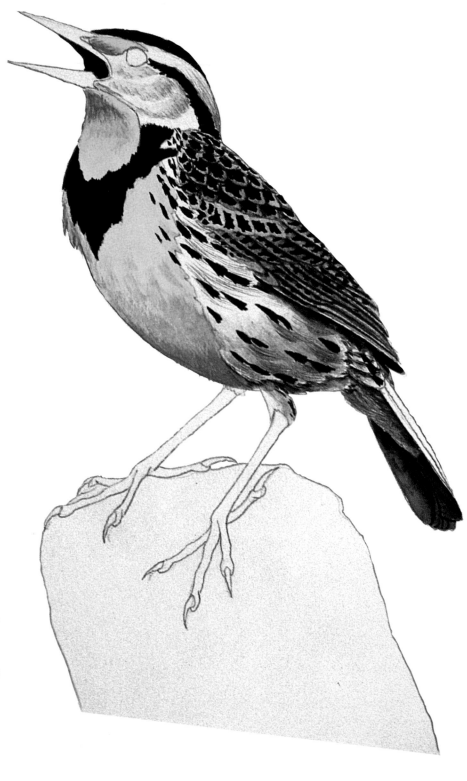

To make the tail appear curved, the gray undertail feathers are graded with a black wash: darkest on the near side and graded lighter toward the middle of the tail. Additionally, the far tail feather is given a thin black wash to separate it more from the undertail coverts. The shadow under the wing is defined with an opaque black line, and the bottom of this line is then softened to show the roundness of the body. Opaque black is painted inside the bill.

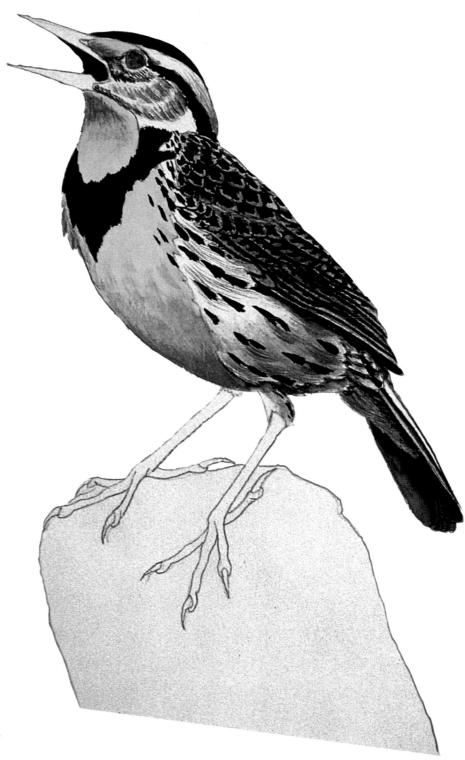

Thinned raw umber is used to paint the iris of the eye and also to draw a thin line along the top of the tail. The wing coverts painted with white earlier were judged to be too light, so a thin wash of raw umber was glazed over them. The feathers around the eye and the ear patch is defined, using thinned black in the #1 round. The #1 round is then loaded with opaque black and a thin, hard line is drawn under each wing feather. Additionally, a black line is painted down the near side of the tail to indicate two feathers.

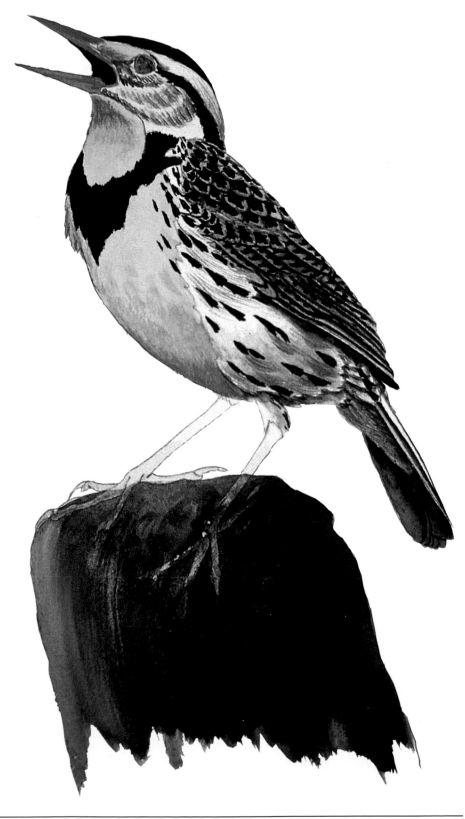

Ultramarine blue, black, and white are mixed, and the base color of the bill is painted in. Liquid masking is applied on the feet and legs where they overlap the post. After the masking is dry, the post is roughed in with a mixture of yellow ochre, raw umber, and black. While this mixture is still wet, white mixed with yellow ochre is brushed on the light side, and black on the shadow side.

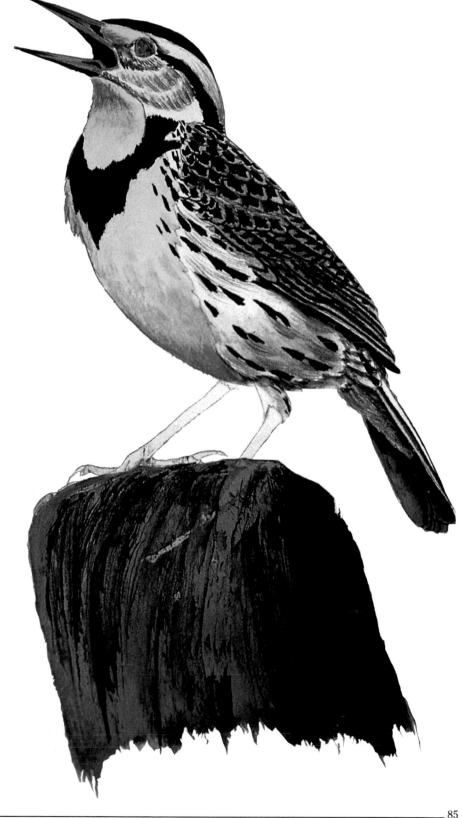

After the post was dry, it was deter-
mined that the base color was too
bright and would compete with the
bird. A mixture of white with very
small amounts of black and raw
umber was drybrushed on the post
for the lighter parts, and pure
thinned black was drybrushed for
the darks. These two colors are dry-
brushed alternately until a realistic
weathered-wood appearance is
achieved. Then a splitbrush loaded
with black is dragged along the
contours created to show cracks.
Additionally, black is painted on the
bill to indicate shadow areas.

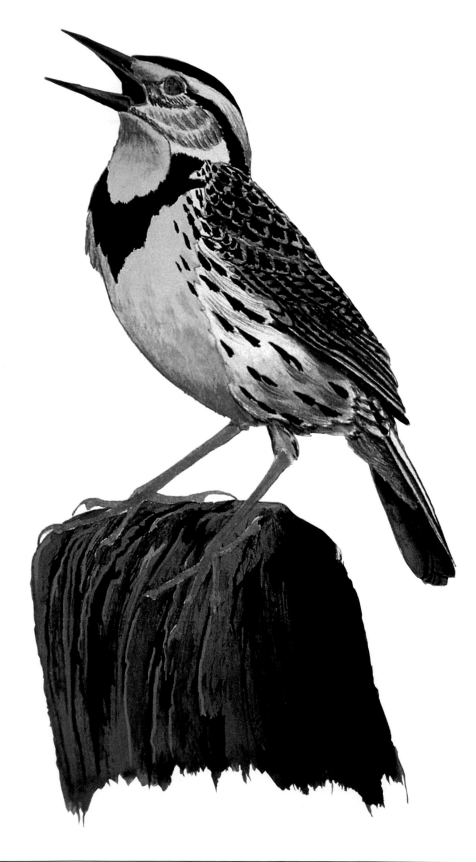

When the post color is dry, remove the masking from the legs and feet and paint them in with a mixture of burnt umber and white. On the post, some random drybrush marks are painted with black to emphasize and define them; this gives the post crisp contours. Thinned white is then painted on the highlight side of the black shadow areas to make them appear to have depth. The black shadow areas on the bill are lightly blended with a clean, moist brush.

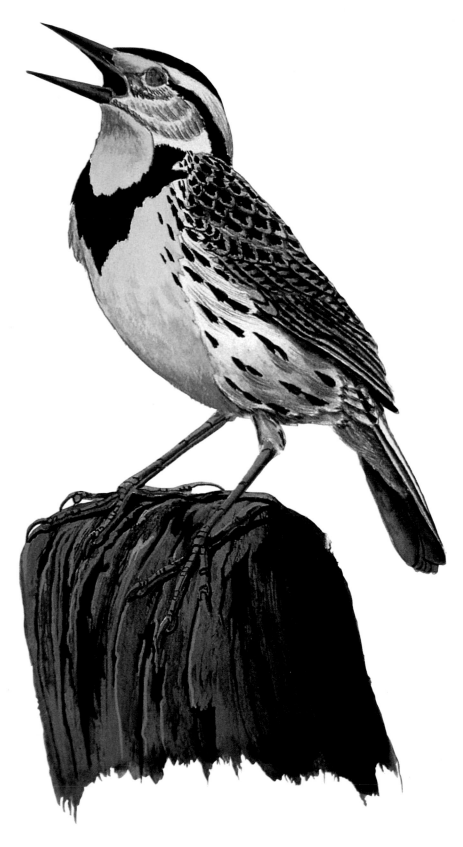

Pure burnt umber is used with the #1 round to draw in the scales on the legs and feet. A thin hard-edge opaque black shadow is painted under each toe and the shadow of the legs is painted over the post.

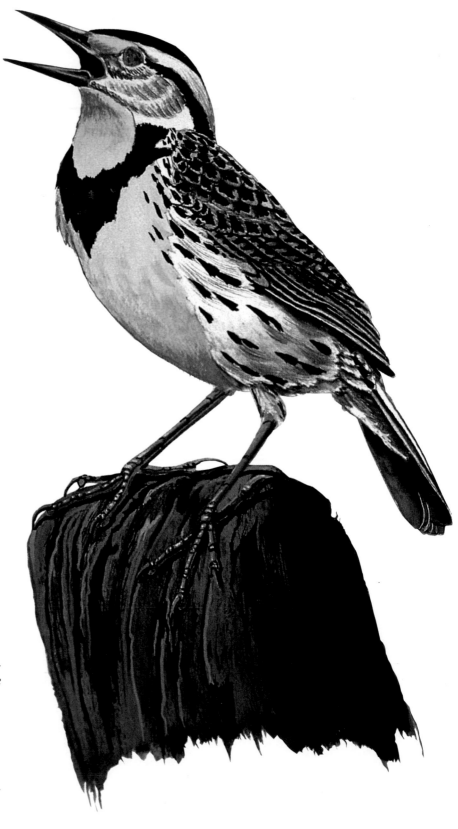

With the #1 round, opaque white is brushed coarsely on the undertail coverts, the back edge of the flank, and the upper leg to give more separation. Additionally, a thin white line is drawn along the edge of each primary and the tips of the undertail feathers. Very dilute white is lightly dabbed on the leg and feet scales to highlight them. Opaque white is used to highlight the bill, and, in the splitbrush, to give some light feather detail to the black bib on the breast.

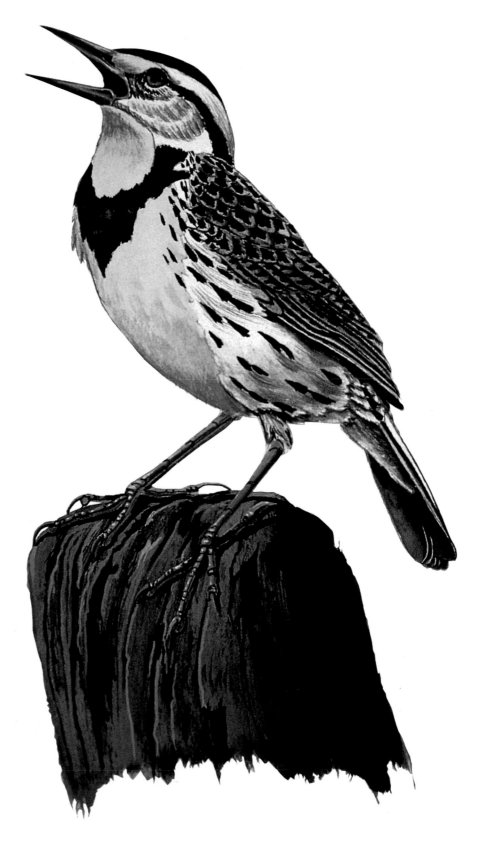

The white added previously to the undertail coverts, flank, and leg is blended into these areas. With the #1 round, black is painted under the scapulars where the leg inserts into the flank, and again along each undertail feather. This serves to further define these areas. The shadow and iris of the eye is roughed in and the area around the eye detailed with black in the #1 round.

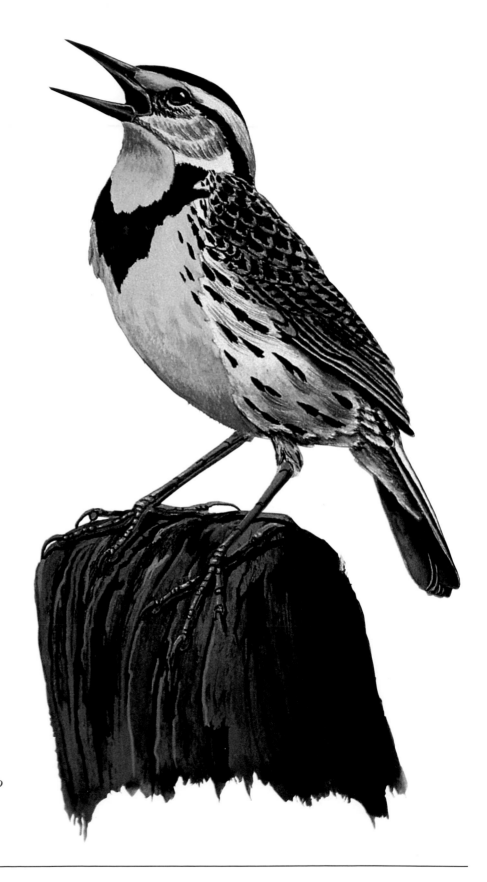

All the final detailing is with the #1 round. The white on the bill is blended and refined, and the dark area under the lore is softened. The eye is completed by carefully blending the shadow area down the iris to give it depth, and with the addition of the opaque white highlight in the eye, the meadowlark comes alive.

8
Practice Birds

Purple Finch

Carpodacus purpureus

The male purple finch is characterized by a stout bill, a deeply forked tail, and a reddish color variously described as wine or raspberry. The color of the wing-feather patterns ranges from brownish black to black. In painting any bird it is important to paint in the proper colors, and this is especially true with the purple finch. The base color should be mixed carefully to be neither too red nor too blue. Make sure your test mixtures dry completely before choosing the proper shade. Notice how many shades of the reddish color are on the finch; build these shades up slowly. The crown may show a lot of highlights and feather separation or be perfectly smooth because purple finches raise and lower their crown feathers frequently.

Palette: white, ivory black, Winsor & Newton raw umber, green, cadmium red pale, ultramarine blue pale, and cadmium yellow middle.

Painting hints: Opaque white is painted on the underparts, then a thin wash of a mixture of cadmium red pale, ultramarine blue pale, and a small amount of cadmium yellow middle is painted over the rest of the bird. This same color mixture is then blended from the throat into the white breast. Then the breast patterns are painted, all with the splitbrush, and tipping is used on the last bits of the breast pattern. On the head and back the darker reds are built up slowly with a mixture of cadmium red pale and ultramarine blue. In the very dark red areas a tiny amount of green darkens the mixture even more. The dark—black-brown or black—patterns are then added to the back, scapulars, wings, tail, and head. The rest of the painting is refined with shading, highlighting, and detailing.

Purple Finch (Larry West photo)

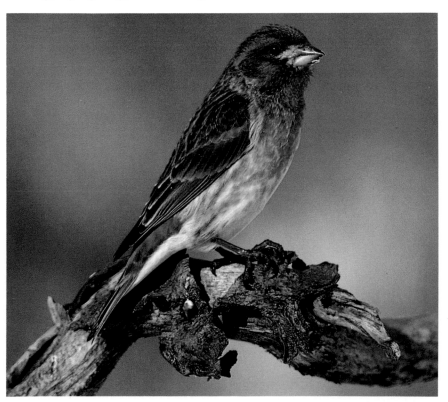

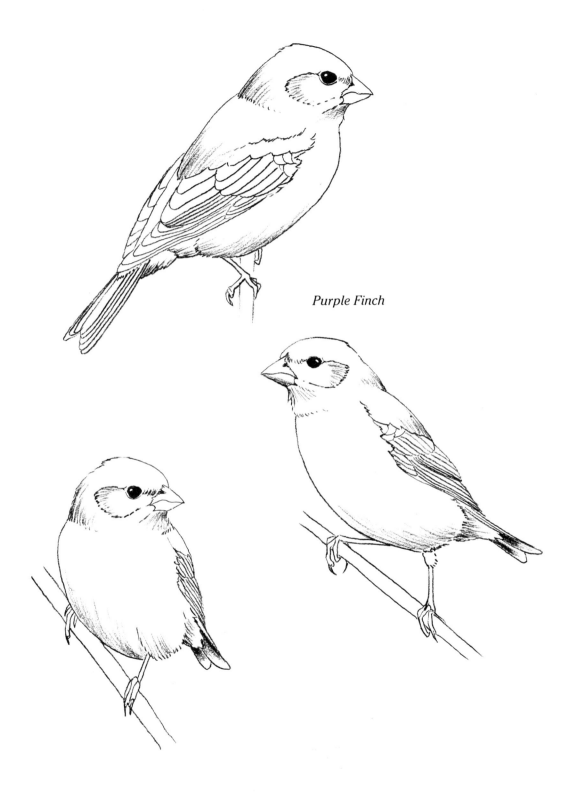

Purple Finch

Evening Grosbeak

Coccothraustes vespertinus

A huge bill, white wing patches on black wings, a yellow body and dark head make the male evening grosbeak a distinctive bird. But look at the head: turned one way it appears to be black, turned another way it looks dark chocolate brown. There is quite a bit of variation depending on the ambient light and the individual bird. The areas where browns blend into the rest of the body are areas where a good deal of splitbrush is used, not smooth blending. There is also variation with the white wing patches. Generally it is the three tertials and just the tips of a few secondaries under them, along with two or three of the topmost secondary coverts, that are white. When painting these white feathers use a *very* light shadow, if any, to separate them, because the white feathers blend together almost perfectly, even if examined close up. When testing the yellow color for the body, add a tiny amount of violet to the yellow (complementary colors) if, initially, the yellow appears too bright.

Palette: white, ivory black, cadmium yellow middle, violet, burnt umber, Winsor & Newton raw umber, yellow ochre, and burnt sienna.

Painting hints: Block in the yellow areas with a wash of cadmium yellow middle. Then paint opaque black on the tail and wings and white on the wings. A base mixture of burnt and raw umber is painted on the head, throat, and back and blended, with a splitbrush, into the yellow. Additionally, these areas are refined and detailed with black. Cadmium yellow middle and a small amount of violet lake are mixed for the shadow areas in the yellow. Burnt sienna and white are mixed for the legs, and yellow ochre thinned with white is used on the bill. Feather-edge detailing on the back of the wings and tail is done with dark gray (black plus white).

Evening Grosbeak (Larry West photo)

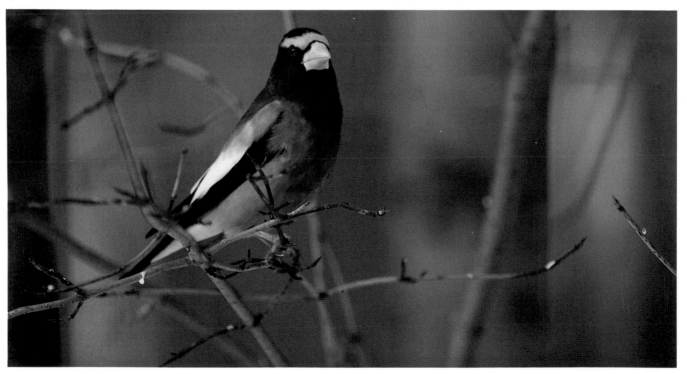

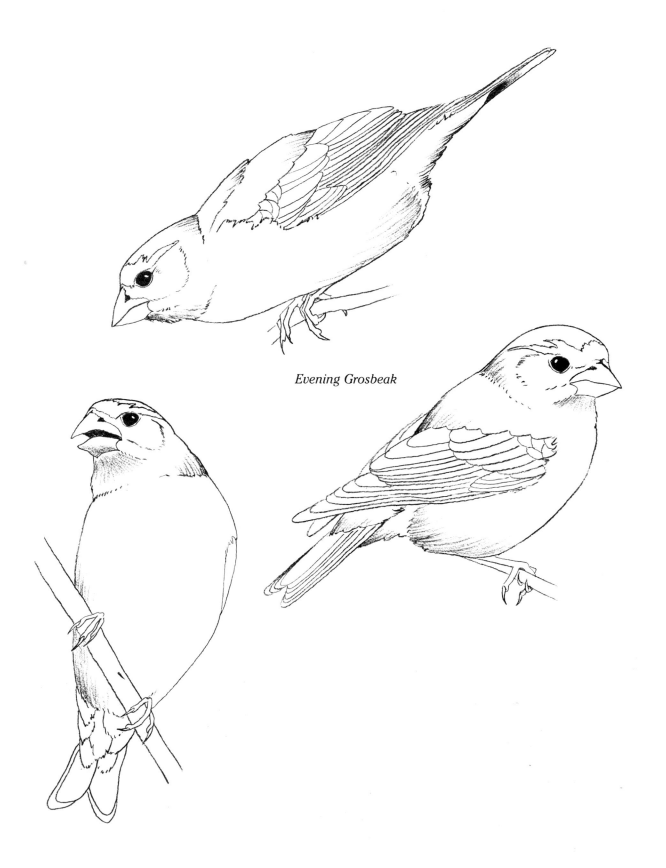

Evening Grosbeak

American Tree Sparrow

Spizella arborea

In this species the male and female are similar, with a rusty-colored crown, two-tone bill, and a dark spot on an unstreaked breast. Additionally, the back, scapulars, and wings are a rusty-brown color with distinct black patterns. The shade of this rusty color can vary from rusty with a reddish cast to rusty with a more brownish cast, depending on the time of year and geographic location. So when looking at additional reference sources, other than the accompanying photograph, don't be confused when you see this color variation. Just mix and paint the color you perceive to be most realistic. Notice the gentle blending of the grayish brown to white on the breast and flank, and also the subtle buffy areas that blend into the rusty colors on the wings and back. These areas must be painted and blended carefully.

Palette: Winsor & Newton raw umber, burnt sienna, ivory black, white, yellow ochre, ultramarine blue pale.

Painting hints: Raw umber and burnt sienna are mixed and thinly painted on the crown, eye line, and whisker (the line that extends downward from the corner of the bill). Then, a thin wash of this same mixture is painted over the back, scapulars, and wing. The gray areas of the head are painted with a mixture of white, black, and a touch of ultramarine blue pale, while the gray on the side that blends into the white is a mixture of white, black, and a touch of raw umber. When all is dry, black is used for the patterns on the back and wings. The buffy color on the wings and back is a mixture of yellow ochre, burnt sienna, and white. Splitbrush on the underparts and flanks, shading, and final detailing finish up the painting.

American Tree Sparrow (Larry West photo)

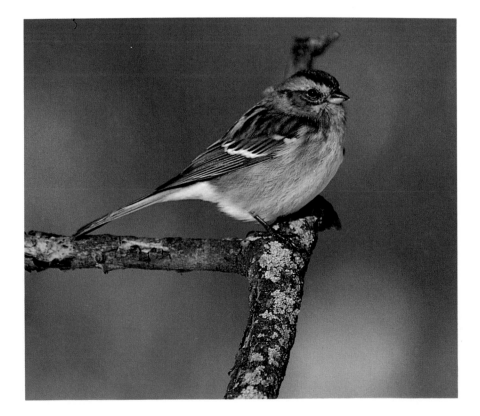

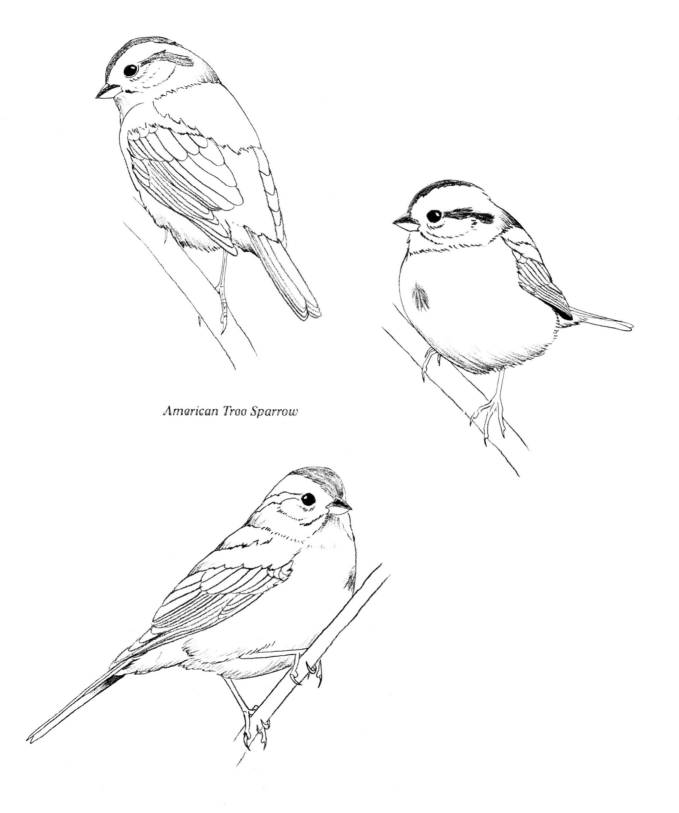

American Tree Sparrow

American Goldfinch

Spinus carduelis

The male goldfinch is unmistakable in its breeding plumage of bright yellow and black. As colorful as it is, the yellow body feathers show very little detail and the black wings and tail show separation only on the white tips. Thus, when painting a goldfinch you must avoid making it look just yellow, black, and flat. Extensive shading and highlighting are needed to emphasize the contour and form that makes the painting believable and lifelike. The shading in the yellow areas is accomplished with a mixture of cadmium yellow pale and a tiny amount of violet (complementary colors), while the yellow highlights are cadmium yellow pale and white. Some feather edges on the wing may be touched with gray, but do not paint every edge or the wing will be overpainted.

Palette: cadmium yellow pale, ivory black, white, violet, cadmium red pale, burnt sienna.

Painting hints: Liquid masking is painted on the wings where large areas of white will show. When the masking is dry, opaque black is painted over the wing, tail, and crown. Cadmium yellow pale is washed wet-in-wet over the yellow areas. If the pure yellow color appears too light, add a *tiny* amount of cadmium red pale to it—this will yield a rich yellow. The liquid masking is removed from the wing and opaque white is painted on; it is also used to detail the white areas of the tail and painted over the undertail coverts. Shading is done on the lower parts of the body, the back of the head, and the lower part of the scapulars. Highlights are added to the yellow of the breast and the top of scapulars. The bill, legs, and feet are painted with a mixture of burnt sienna and white.

American Goldfinch (Larry West photo)

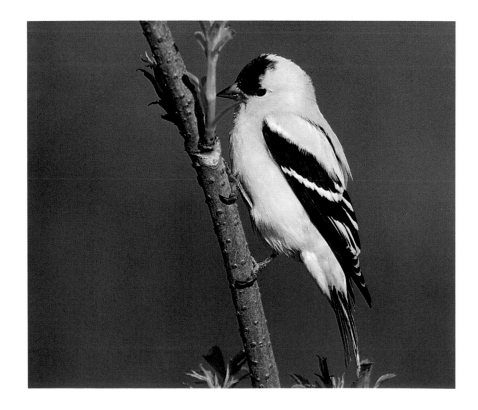

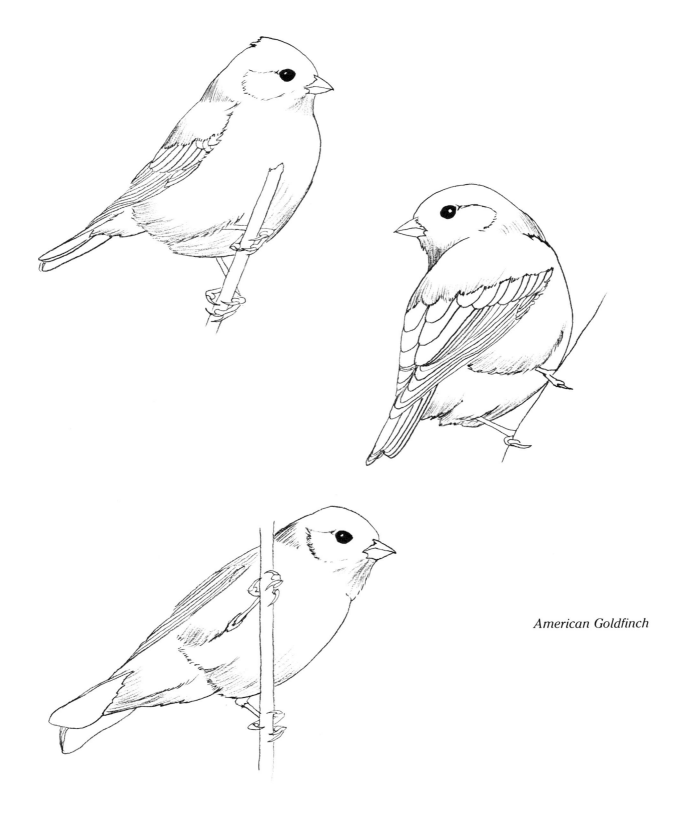

American Goldfinch

Robin

Turdus migratorius

A common mistake in bird painting is that a bird is overpainted because the artist adds more detail than actually appears in nature. With the majority of robin paintings the opposite occurs and the bird is simplified and underpainted. Although seemingly easy to paint, the robin has a good deal of color variation and shading, thus requiring accurate color mixing and careful blending to achieve a realistic painting. The correct color of the gray areas is a mixture of white, black, ultramarine blue, and burnt sienna; tests of various proportions of colors of this mixture should be made before choosing the proper shade.

Palette: white, ivory black, ultramarine blue pale, burnt sienna, cadmium red pale, cadmium yellow pale.

Painting hints: The orange breast is a mixture of cadmium red pale, cadmium yellow pale, and a small amount of burnt sienna. Opaque white is used for the undertail coverts. A thin mixture of the proper gray color is washed wet-in-wet over the dark upper areas, including the head and tail. A darker mixture of the gray is made by adding more black to the basic color and is used for the patterns of the back, scapulars, and wing; these patterns are blended when appropriate. A light gray details the feather edges. Thin black is washed over the head and tail and is used to shade the undertail coverts and breast. Light splitbrushing with cadmium yellow pale adds highlights to the breast. Opaque white is used to detail the wings, throat, and eye area. Cadmium yellow pale mixed with burnt sienna creates the bill color.

Robin (Rod Planck photo)

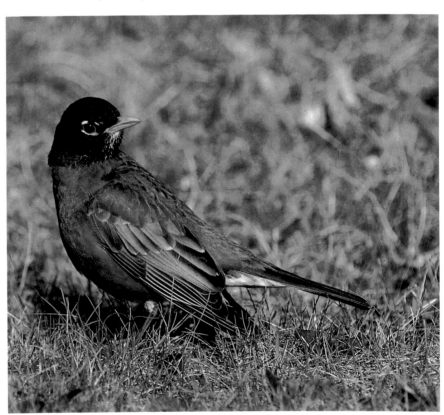

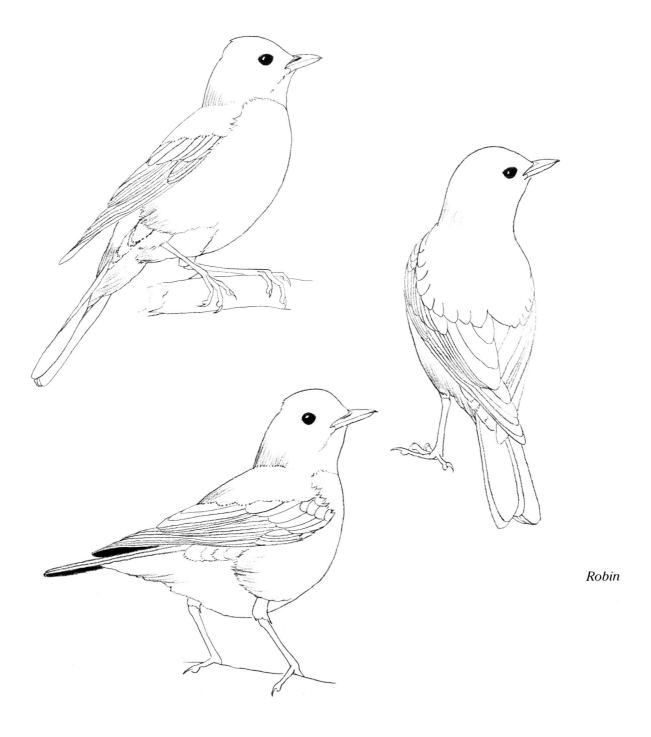

Robin

Marsh Wren

Cistothorus palustris

The brown colors of this tiny acrobatic wren are subtle and variable, depending on the quality of the light in which they are seen. The photograph depicts one in rather strong sunlight, thus, the overall appearance of the various browns is rather light. The marsh wren is not a bird with a smooth outline, so care must be taken not to make it look too slick. This is accomplished by breaking up the body outline in appropriate places: the throat, flanks, and undertail coverts. To emphasize feather separation, a light shadow should be painted opposite the highlighted area where each feather is separated. Though the scapulars are not visible in the photograph, they are a reddish brown mixture of burnt umber and burnt sienna.

Palette: white, ivory black, burnt umber, yellow ochre, Winsor & Newton raw umber.

Painting hints: Thinned white is used for the throat and lighter parts of the lower body. A mixture of white, burnt umber, and yellow ochre is thinned and washed over the brown upperparts, including the crown. Thinned black is used for the dark bars on the wing and tail feathers, and for the light patterns on those areas a mixture of white with a small amount of raw umber is the correct color. The buffy color on the flanks and breast is a mixture of the same colors used on the upperparts but with more yellow ochre and thinned heavily. This color is applied with the splitbrush to achieve a loose, feathered look. The crown is tipped with black to indicate tiny dark feathers over the brown wash. Gray shading is done on the white areas. Opaque white details the line above the eye and opaque black is used to delineate the individual wing and tail feathers.

Marsh Wren (Rod Planck photo)

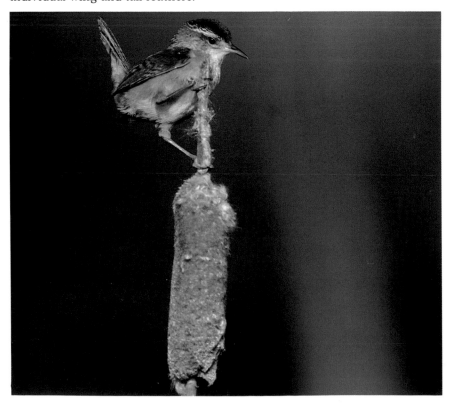

Marsh Wren

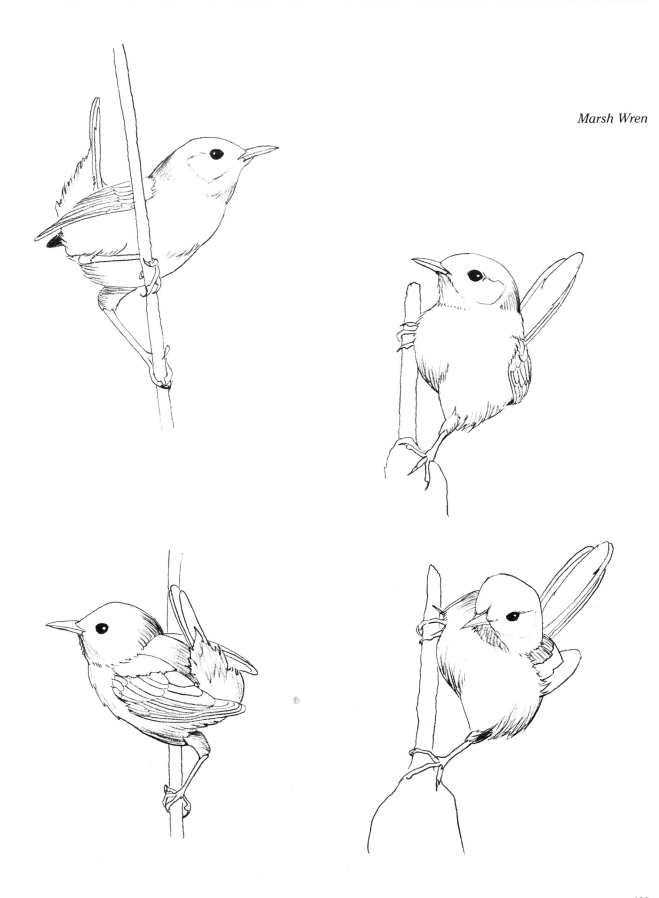

Hermit Thrush

Catharus guttatus

The back, scapulars, and wings of the hermit thrush appear to be a rather drab brown, and although the color is not a lively one, it can be tricky to mix. One should avoid having it look like a dirty brown, which, in nature, it is not. The correct color is a mixture of raw umber, yellow ochre, and burnt sienna. To achieve a realistic look to the teardrop-shaped black breast spots, the painted spots should follow the contour of the breast and should *not* be aligned with one another.

Palette: Winsor & Newton raw umber, burnt umber, yellow ochre, burnt sienna, white, and ivory black.

Painting hints: Burnt umber and burnt sienna are mixed and used for the tail and upper-tail coverts. The rest of the brown upperparts are done in a thin wash of yellow ochre, raw umber, and burnt sienna. Opaque white is painted around the eye and ear patch, then down the throat, covering all the underparts, including the undertail coverts. Thin black is used for the faint wing patterns and opaque black for the breast spots. Burnt sienna and yellow ochre are mixed and used opaquely to detail the edges of the tail feathers and the edges of the primaries. The leg color is a mixture of raw umber, white, and burnt sienna. White and the brown crown color are brushed alternately about the head area until a realistic effect is achieved. The bill is a dark gray with a yellow-ochre-and-white mixture at the base. Shading the white underparts with thin black and adding light detailing to the wing feathers and back will complete these areas.

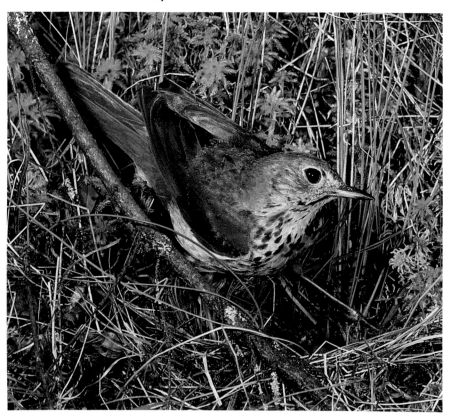

Hermit Thrush (Larry West photo)

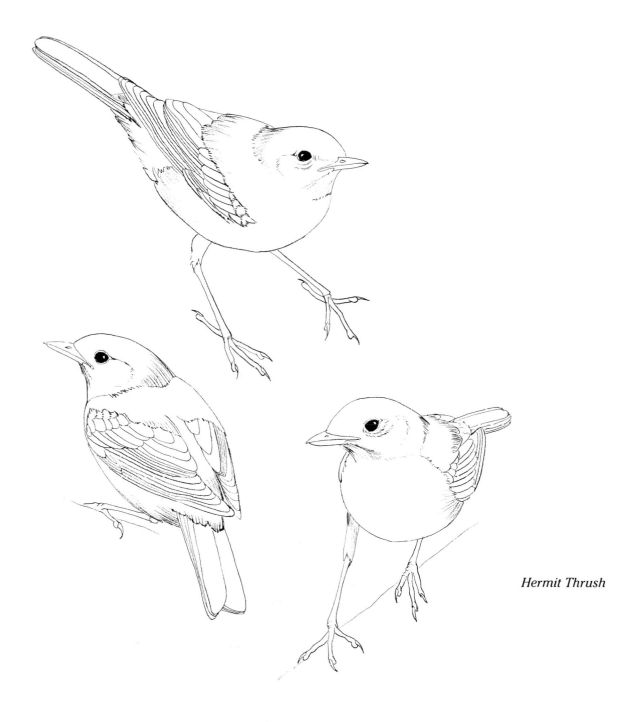

Hermit Thrush

Blue Jay

Cyanocitta cristata

The blues in a blue jay can be troublesome to mix to the proper shade; only trial and error with a lot of testing will enable you to get the correct blues. Notice the differences between the blue of the back, wing feathers, and tail. Additionally, the degree of reflected bright blue on the crown depends on how much the crest is raised or lowered. The splitbrush is used extensively on the breast for blending to achieve a distinctive feathered appearance.

Palette: ultramarine blue pale, cadmium red pale, white, phthalo blue, and ivory black.

Painting hints: Apply liquid masking on the tips of the secondary coverts, which will be white. Mix ultramarine blue, black, and a small amount of cadmium red pale to the proper shade for the crown, neck, back, and scapulars. The blue of the wing and tail is a mixture of ultramarine blue, phthalo blue, and white. When the wing is painted and dry, the masking is removed and opaque white is used for the white patterns; it is also used for the appropriate head and lower-body areas. Ultramarine blue, black, and white are mixed and splitbrushed over the breast and flank areas. Opaque black is used to paint the patterns on the head, wings, and tail and to detail the shadows under the wing and tail feathers. The bright blue wing color is lightly tipped onto the crown to indicate highlighted blue feathers. Shading the flanks, breast, and neck with thin black, and detailing the bill, head, and feet finishes the blue jay.

Blue Jay (Larry West photo)

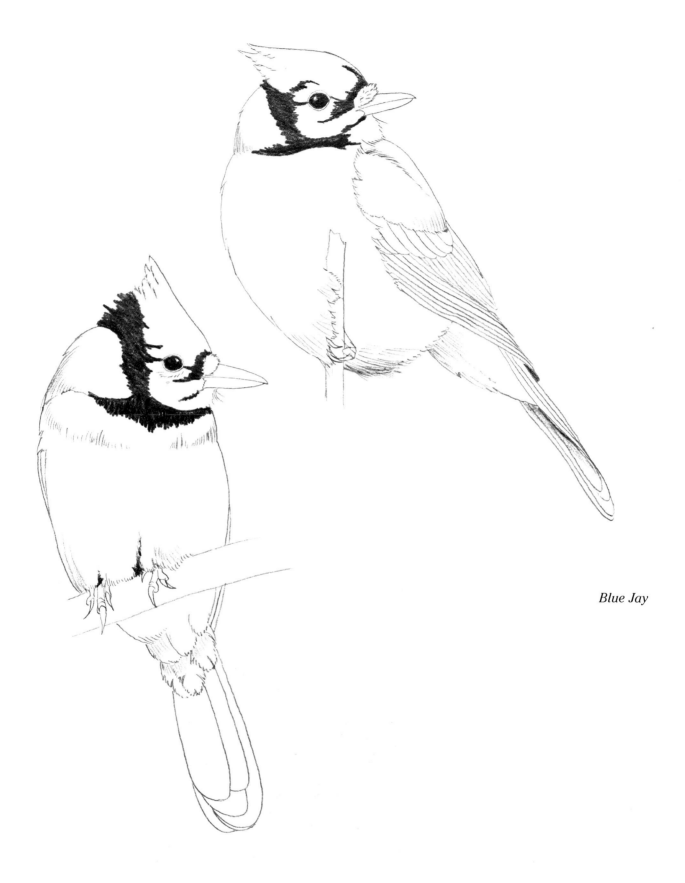

Blue Jay

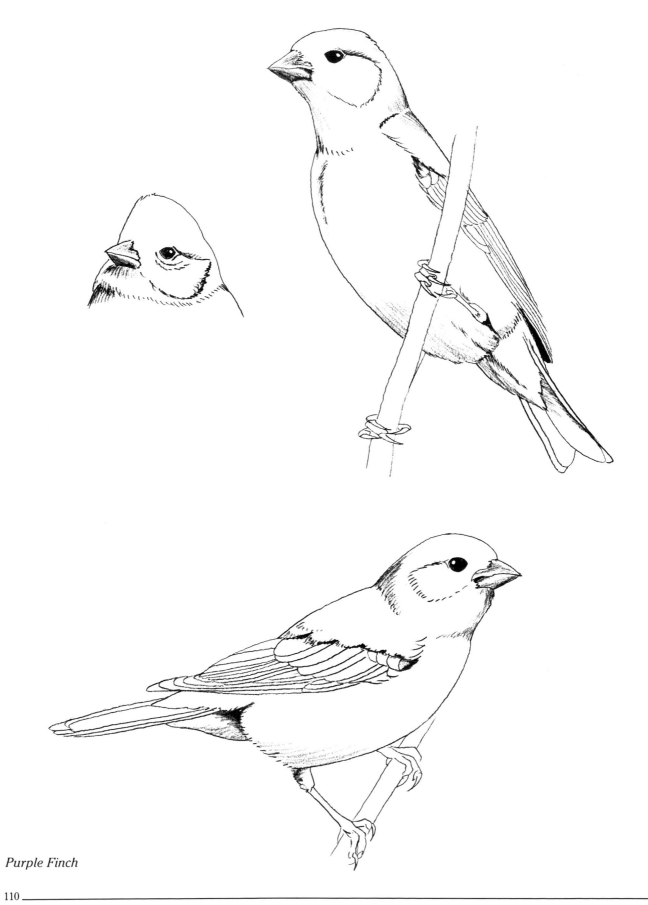

Purple Finch

Purple Finch

Purple Finch

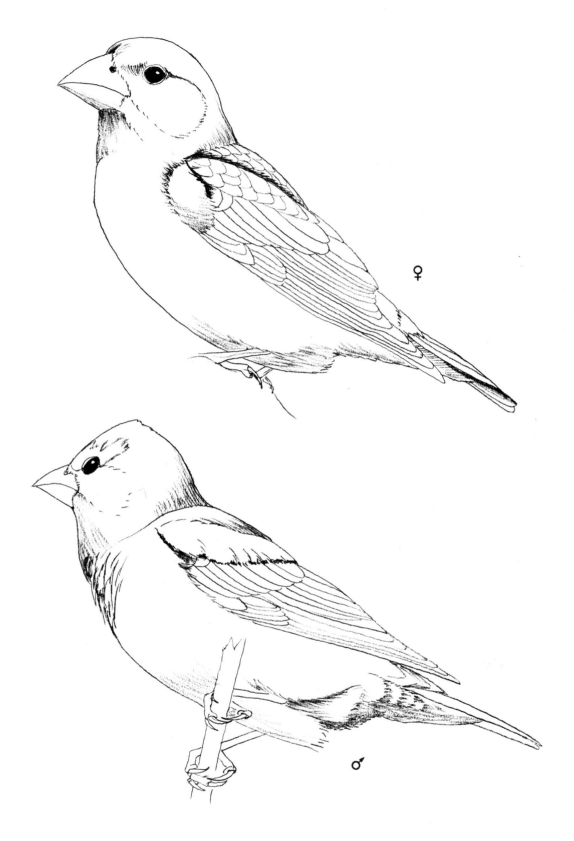

♀

♂

Evening Grosbeak

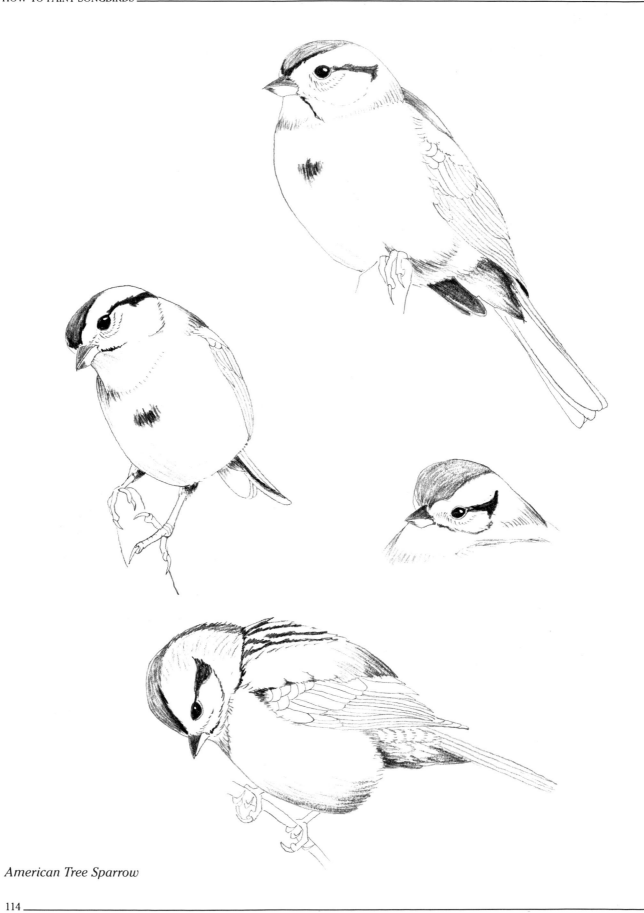

American Tree Sparrow

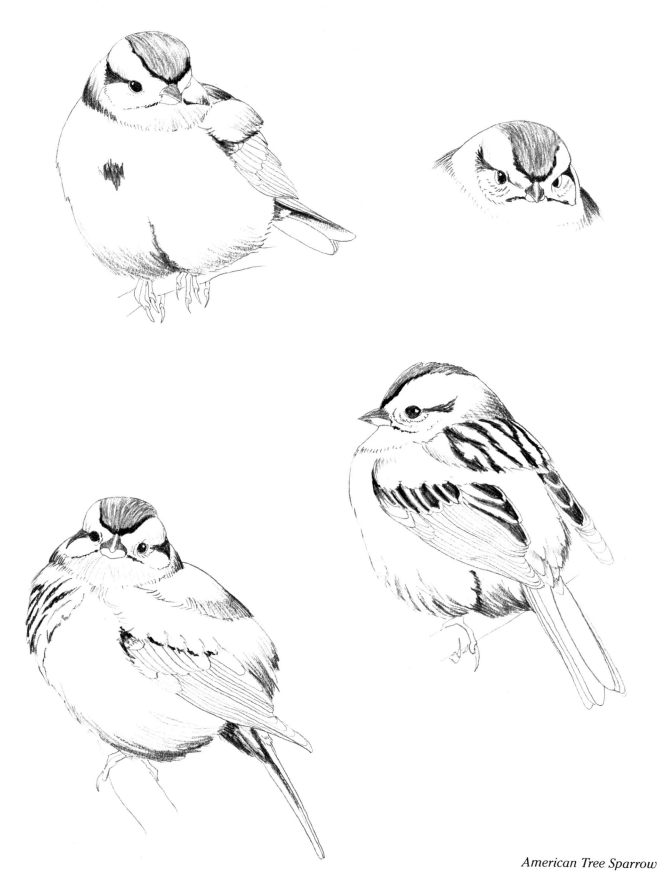

American Tree Sparrow

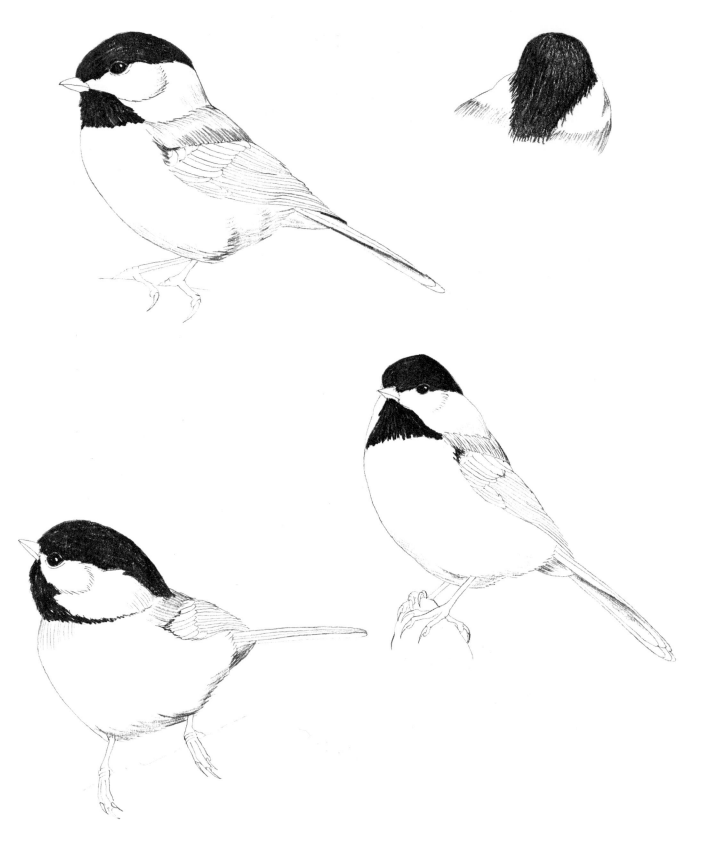

Black-Capped Chickadee

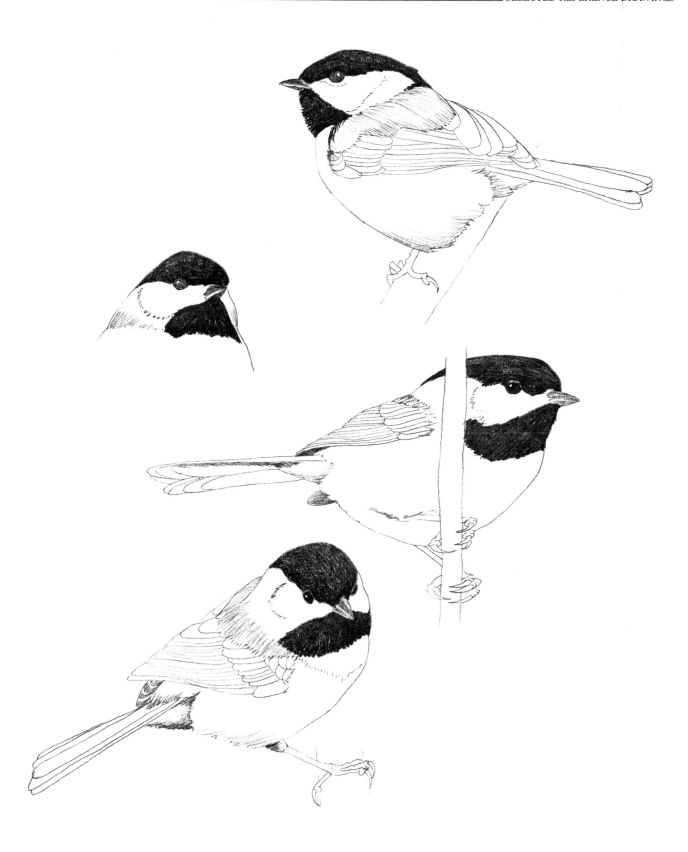

Black-Capped Chickadee

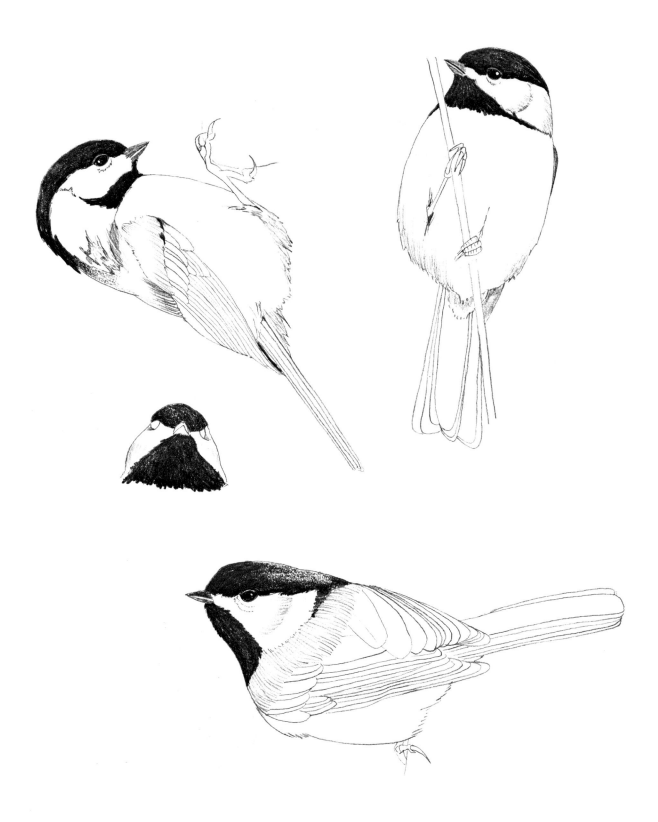

Black-Capped Chickadee

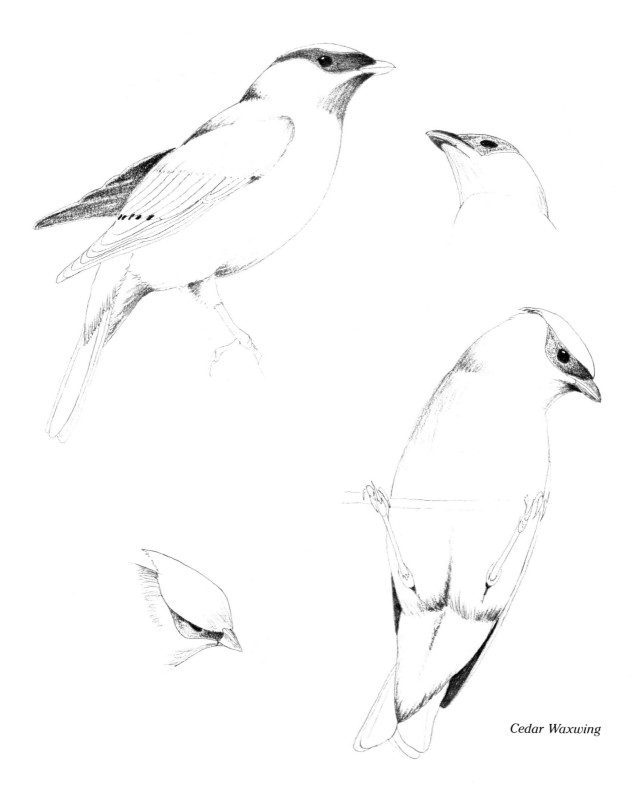

Cedar Waxwing

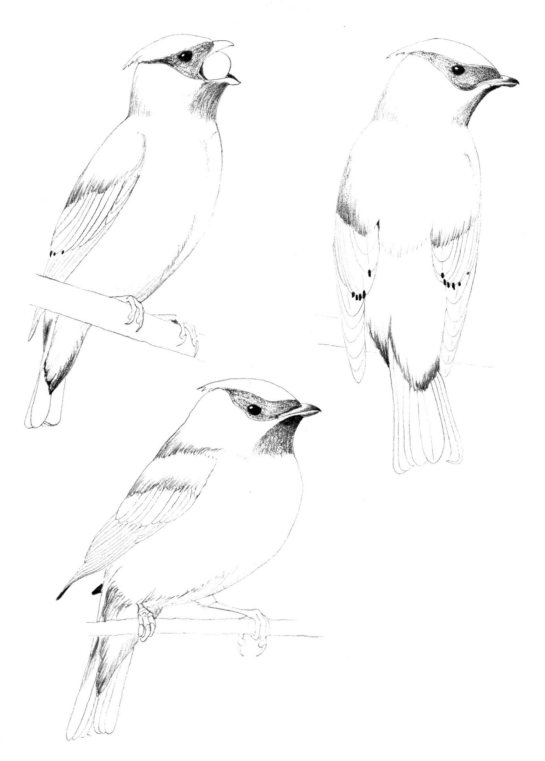

Cedar Waxwing

10
Reference
Material

 A frequent problem bird artists have is in obtaining adequate reference material. Although there is no substitute for observing the colors, attitudes, postures, and habits of birds in the wild, other reference sources must be considered because few of us have the ability to remember the field marks, color, and shape of a particular bird well enough to paint it accurately in the studio. However, when examining several reference sources, especially photographs and printed material, for a specific species of bird, you will notice wide variation in color for that bird from different sources. These color variations are due to many factors, ranging from the time of day a photograph was taken (flat midday light or warm afternoon light) to the accuracy of the printer in reproducing a color. The artist must choose his reference material carefully so that he can accurately portray the bird as he perceives it. The following are suggestions for sources of reference material.

Photographs. Most wildlife artists have a 35mm camera and telephoto lens to take their own reference photos of birds in the outdoors, whether in the wild or at the feeder. Original photos are an excellent source of material; however, they should be used as an aid, not as a crutch. Unfortunately, many bird artists rely exclusively on photographs they copy directly. Thus, their pictures are merely renderings of photographs—a far cry from original art.

Nature Centers, Sanctuaries, and Zoos. All these provide the opportunity to observe live birds, caged and free. Be aware that some physical features may be affected by captivity. Caged birds may have tattered wings and broken bills from flying against the cages. Also, some of the birds, especially at sanctuaries and nature centers, are brought in injured and could have broken wings or other disfiguring injuries that should be taken into account. Some loose yet captive birds are pinioned (wing tip removed) to prevent flight; this means there is only one complete wing. Though this reads like a list of horrors, such birds are well cared for and afford the artist an opportunity to closely observe birds that are very difficult to see in the wild, even at a distance.

Books and Magazines. Both contain art and photographs that may be used for reference; most bird artists have files of material saved from magazines and other printed sources. There are scores of bird art books, some of which are useful sources of general reference. The rule here is: Don't use other artists' work as the *only* source of reference, for if an error was made in the original art, you will perpetuate it. Only use the art of others in conjunction with other reference material.

Preserved Specimens. Museums and nature centers usually have collections of preserved birds, as study skins, mounted in lifelike poses, or frozen, awaiting preparation. If you can gain access to these collections, they are excellent sources of reference material. The anatomical accuracy of mounted specimens may vary greatly, depending on how long the bird has been mounted and the skill of the preparator. Again, there are things to be aware of. As soon as a bird dies, even if it is frozen immediately, it loses, for lack of a better term, its "life force." It becomes smaller as everything collapses, and colors begin to fade immediately, especially in the legs and bill. Road and window kills also suffer the loss of "life force" and fading, and, additionally, there are state and federal laws governing the possession of songbirds, dead or alive, without a special permit. Before keeping any

specimens, investigate local and federal laws with your state conservation department.

Carvers' Supply Sources. These stores sell feet, bills, and occasionally heads cast from actual songbird specimens. A good reference source.

Reference Books

Audubon Society. *Field Guide to North American Birds Eastern Region*. New York: Alfred A. Knopf, 1977.

———. *Master Guide to Birding*, 3 Vol. New York: Alfred A. Knopf, 1983.

Austin, Oliver L. and Arthur Singer. *Birds of the World*. New York: Golden Press, 1961.

Burn, Barbara. *North American Birds*, The National Audubon Society Collection Series. New York: Bonanza Books, 1984.

Carlson, Kenneth L. and Laurence C. Binford. *Birds of Western North America*. New York: Macmillan Publishing, 1974.

Casey, Peter N. *Birds of Canada*. Ontario: Discovery Books, 1984.

Ede, Basil. *Basil Ede's Birds*. New York: Van Nostrand Reinhold, 1981.

Epping, Otto M. and Christine B. Epping. *Eye Size and Eye Color of North American Birds*. Winchester, Va.: Privately printed, 1984.

Gromme, Owen J. *Birds of Wisconsin*. The University of Wisconsin Press, 1974.

Holt, T. F. and S. Smith, eds. *The Artists Manual*. New York: Mayflower Books, 1980.

Hosking, Eric. *Eric Hosking's Birds*. London: Pelham Books, 1979.

Jeklin, Isidor and Donald E. Waite. *The Art of Photographing North American Birds*. British Columbia: Whitecap Books, 1984.

Lansdowne, J. F. *Birds of the West Coast*, 2 Vol. Boston: Houghton Mifflin, 1980.

Lansdowne, J. F., with J. A. Livingston. *Birds of the Northern Forest*. Boston: Houghton Mifflin, 1966.

Lansdowne, J. F. and J. A. Livingston. *Birds of the Eastern Forest*, 2 Vol. Boston: Houghton Mifflin, 1970.

Mohrhardt, David. *Bird Reference Drawings*. Berrien Springs, Mich.: Oak Bluff Press, 1985.

———. *Bird Studies*. Berrien Springs, Mich.: Oak Bluff Press, 1986.

———. *Selected Bird Drawings*. Berrien Springs, Mich.: Oak Bluff Press, 1987.

Perrins, Christopher M. and Alex L. A. Middleton. *The Encyclopedia of Birds*. New York: Facts on File Publications, 1985.

Porter, Eliot. *Birds of North America*. New York: E. P. Dutton, A&W Visual Library.

Robbins, Chandler S., et al. *A Guide to Field Identification—Birds of North America*. New York: Golden Press, 1966.

Saitzyk, Steven L. *Art Hardware*. New York: Watson-Guptill, 1987.

Scott, Shirley L., ed. *Field Guide to the Birds of North America*. Washington, D.C.: National Geographic Society, 1985.

Terres, John K. *The Audubon Society Encyclopedia of North American Birds*. New York: Alfred A. Knopf, 1980.

Tunnicliffe, C. F. *A Sketchbook of Birds*. New York: Holt, Rinehart and Winston, 1979.

———. *Sketches of Bird Life*. London: Victor Gollancz Ltd., 1981.

———. *Tunnicliffe's Birds*. Boston: Little, Brown and Company, 1984.

Wetmore, Alexander. *Song and Garden Birds of North America*. Washington, D.C.: National Geographic Society, 1964.

General Art Suppliers

There are many suppliers of general art supplies. Here are just a few, and most have a fee for their catalogs.

Pearl
308 Canal Street
New York, N.Y. 10013

Dick Blick
Box 1267
Galesburg, Ill. 61401

Arthur Brown & Bros. Inc.
P. O. Box 7820
Maspeth, N.Y. 11378

Daniel Smith Inc.
4130 1st Avenue S.
Seattle, Wash. 98134

Christian Hummul Co.
404 Brookletts Avenue
P. O. Box 1849
Easton, Md. 21601

Craft Cove
2315 W. Glen Avenue
Peoria, Ill. 61614

Wildlife Artist Supply Co.
P. O. Box 1330
Loganville, Ga. 30249

Product Manufacturers

Manufacturers will supply product information, color charts, and the names of local suppliers.

Koh-I-Noor Inc.
100 North Street
Bloomsbury, N.J. 08804
 Pelikan gouache

Winsor & Newton
555 Winsor Drive
P. O. Box 1519
Secaucus, N.J. 07096
 Acrylic paints and media
 Gouache paints and media
 Brushes

Robert Simmons Inc.
45 W. 18th Street
New York, N.Y. 10011
 Brushes

H. K. Holbein Inc.
Box 555
Williston, Vt. 05495
 Gouache

Fredrix/Tara
111 Fredrix Alley
Lawrenceville, Ga. 30246
 Artist canvas
 Watercolor paper

Crescent Cardboard Co.
P. O. Box XD
100 W. Willow Rd.
Wheeling, Ill. 60090
 Watercolor board
 Illustration board

Strathmore Co.
Westfield, Mass. 01085
 Watercolor paper
 Brushes

Grumbacher Inc.
Cranbury, N.J. 08512
 Brushes
 Paints
 Canvas

Delta
2550 Pellissier Place
Whittier, Calif. 90601
 Shiva Acrylics
 Brushes

Binney & Smith Inc.
1100 Church Lane
P. O. Box 431
Easton, Pa. 18044
 Liquitex Acrylic

Glossary

Acrylic Gesso. An acrylic polymer emulsion that can be either white or gray/black and serves as a ground for acrylic paints. This is not a true gesso as is used in oil painting.

Acrylic Paints. Pigments that are bound together with synthetic resins or polymer emulsions. Water based, they dry fast and hard and are not water-soluble when dry.

Binder. The substance used to coat and hold pigment in suspension and bind the pigment particles together when dry.

Blending. Bringing the edges of two colors together and mixing them to form a smooth transition rather than a hard line.

Blends. The combination of synthetic filaments and natural hairs used in the manufacture of brushes.

Boards. A paperboard of varying thickness that has a drawing, painting, or colored paper adhered to one side. Illustration, watercolor, and mat boards are all paperboards.

Bristle. The stiff rigid body hair of hogs and pigs, characterized by split ends on each bristle.

Canvas. Any woven fabric used as a painting surface. The two most common fabrics are cotton and linen, and they are classified by thread count and ounces per square yard. The finest canvas available is made from Belgian linen.

Complementary Colors. Colors opposite each other on the color wheel that, when mixed together, have a neutralizing or toning-down effect on the other; for instance, to tone down a bright yellow, add a very small amount of violet. The diagram shows a simple color wheel with the primary colors—red, yellow, blue—and their complementary colors. Orange is the complement of blue, green of red, and violet of yellow.

Consistency of Paint. Refers to the viscosity—thickness or thinness—of paint.

Designers Colors. See Gouache.

Detailing. Painting fine-line details on a picture or carving.

Dimension. In painting, refers to shading that gives shape, separation, or roundness to a form.

Drybrush. The technique of painting with very little paint in the brush to produce broken irregular lines or shapes.

Earth Tones or Colors. Naturally occurring in organic pigments that contain clay or silica, they are processed and produce very permanent colors, such as raw umber and raw sienna.

Ferrule. The metal, plastic, or quill sheath that holds hairs to the handle of a brush.

Filament. Any synthetic materials used in the manufacture of artificial brush hairs.

Filberts. Flat brushes that have rounded ends.

Finish. Describes the surface texture of a paper or board: hot press has a smooth finish, cold press has a medium finish, rough has an irregular finish.

Flats. Flat brushes with squared ends.

Flow Release. Synthetic or natural (ox gall) wetting agents that reduce the surface tension of paints, increasing their ability to flow more evenly.

Frisket. See Masking.

Fugitive Colors. Colors that are not stable and that fade or disappear over time.

Gels. Thickening agents added to paints that increase the impasto effect.

Glazing. Painting a thinned color over a dry base color so that the two mix visually and some of the base color shows through.

Gouache. (*Opaque Watercolor, Designers Colors*). A water-based opaque paint made with pigments, a gum binder, zinc white pigment, and other additives.

Grading. Creating a smooth transition from pure color to clear or no color.

Ground. A painting surface that serves as an absorbent stable base for the paint; for instance, acrylic gesso is a ground for acrylic paint.

Gum Arabic. A natural gum from the acacia tree, used as a binder for both gouache and transparent watercolor. It may also be added separately to give extra transparency.

Hair. Used in brushes, it is flexible and has a great degree of absorbency. The amount of spring, absorbency, and shape depends upon the animal the hair is from.

Hardboard. A composition-wood fiber board used in the construction industry. In its untempered form it provides a good painting surface when prepared with a ground.

Highlight. To emphasize an area on a painting surface that would catch and reflect intense light.

Impasto. Paint applied thickly to give a three-dimensional quality.

Lifting Off. A subtractive technique of moistening and removing dry paint.

Load. The amount of paint carried in the hairs of a brush. A full load is where the hairs are thoroughly saturated but not dripping.

Masking. Blocking out an area with liquid masking or paper to form a barrier that does not allow paint to penetrate its surface.

Matte Finish. A flat nonglossy finish.

Medium. The material in which an artist works or which, used as an additive, alters the materials.

Oil Paint. Pigments that use oils as binders and that require solvents and oils as thinning agents.

Opaque. The quality of a paint to cover a surface and not allow light to pass through it.

Opaque Watercolor. See Gouache.

Ox Gall. See Flow Release.

Ox Hair. Blunt hair from ox ears. Used in brushes, it is dyed red and called sableline.

Palette. Any surface used to hold concentrated paint for paintings.

Permanence. The degree of light-fastness of a color, the longevity of which depends upon many factors, including ingredients used in manufacturing, light, humidity, and pollutants.

Pigment. Coloring matter that is derived from natural or synthetic sources. Also used as a synonym for paint or color.

Premixed Colors. Shades of colors mixed by the manufacturer.

Retarder. An additive that slows the drying time of paints.

Round. The most commonly used watercolor-brush shape. The hairs are in a round ferrule and should come to a fine point.

Sable. Hairs in this category are from various members of the weasel family. They are generally characterized as having a fine point and great spring and strength. Kolinskys are the finest hairs in this group and come from the Asian mink found in Siberia.

Sableline. See Ox Hair.

Softening. Lightly brushing along the edge of a hard line to blend it slightly.

Soluble. Capable of being dissolved by a particular substance.

Splitbrush. Fanning the hairs of a brush until they split apart.

Tipping. Touching only the tip of a brush to a surface and lifting or dragging it to produce various marks.

Tone. General coloring of an area.

Tooth. The texture of a surface, whether paper or gesso, which influences how the paint will appear. A smooth surface has less tooth than does a rough surface.

Transfer. The act of transferring or duplicating a drawing from one surface to another.

Transparent. In painting, the quality of paint that allows light to pass through it.

Transparent Watercolor. A water-based paint with a high concentration of finely ground pigments in a gum arabic binder.

Visual Weight. The perceived impact, brightness, and depth of a color.

Wash. The application of paint thinly or transparently: may be a continuous (even) tone, graded or glazed.

Watercolor Paper. Handmade or machine-made, a variety of fibers are used in their manufacture, including wood pulp, bark, cotton, and combinations of these. The finest papers are made from 100% cotton fibers.